free your inner artist

using your feelings, courage and imagination

Penny Stanway

Illustrations by Penny Stanway

Stobart Davies

Published by
Stobart Davies Ltd, Stobart House, Pontyclerc, Penybanc Road
Ammanford, Carmarthenshire SA18 3HP
www.stobartdavies.com

British Library Cataloguing in Publication Data

A CIP record for this book is available from the British Library

ISBN: 978-0-85442-181-7

Typesetting and Design by: Stobart Davies Ltd, Ammanford, Carmarthenshire

Illustrations: © Penny Stanway

Printed by: Akcent Media Limited

Disclaimer: The information in this book is given in good faith and is believed to be correct at the time of publication.

Front cover: *Marmalade and Silver, 2009*

I use up leftover acrylic paint by daubing it on to a fresh board or canvas, and the resulting shapes and colours sometimes suggest a new picture. The first inkling of these cats sparked off this way and a little titivation made them clearer

acrylic on board, 60x49cm (23½x19¼in)

Contents

Dedication and acknowledgements

This book is dedicated to my sister, the artist, writer and therapist Jenny Hare, because her passion for painting and writing is truly inspirational.

Warm thanks are due to John Simpson – by far the most influential of my art teachers – for helping me to 'see' my painting and overcome my belief that there was a 'right' way to be an artist; to Andrew Stanway, my husband, for his love, interest and encouragement; and to Jane Evans, my editor, for her design sense and expertise.

For more of Penny's paintings and for extracts from *Free Your Inner Artist*, see www.pennystanway.com

Introduction

Free Your Inner Artist is about that magical quality which makes some artists' work especially attractive and rewarding and enables many would-be artists to start painting in the first place. This quality is our 'inner artist' – the creative energy at the very core of our being. It can be surprisingly potent. Its fire gives us the strength, confidence and ability to express our own personal way of seeing and understanding. And its honesty and fidelity reflect the innermost secrets of our being. For these reasons alone it is a priceless asset for those artists seeking to fulfil their innate potential because it enables them to use their understanding, emotion, desires, dreams, challenges, intuition, yearning and sense of the awe and mystery of life to enrich their painting.

Many artists paint attractive pictures because they have excellent powers of observation and judgment and are technically skilled. While some of this group don't need, or want, to boost their creativity, others will find it beneficial. In contrast, many artists who paint mainly intuitively can improve their work and their delight in it if they become more technically adept. As artists we each have some combination of creative energy and technical ability. The trick is to develop the mix that's best for us.

If our inner artist lies dormant or is shut away, its vigour dampened or extinguished, we may not paint at all, or our paintings may be dull, lifeless and lacking in creative sparkle and shine. *Free Your Inner Artist* shows you how to release your creativity so your paintings are suffused with your unique awareness, imagination, symbols and style.

Freeing your creativity by empowering your inner artist doesn't just make for more expressive paintings. It also encourages happiness – even bliss – and puts you more in touch with your environment and the people around you. It can help you relax, release memories and manage adversity.

It also offers three special gifts. First is the thrill of making your own truly personal mark; second, the relief of communicating from body, soul and psyche, rather than just the rational, thinking side of your brain; and third, the privilege of expressing your personal awareness of truth and beauty. Most exciting, perhaps, is the way that freeing creative energy can illuminate our spiritual journey as we walk along the 'road less travelled' in our quest for the meaning of life. Lastly, because creative artists tend to see life from different perspectives, our work can influence how others perceive, understand and even act in the world.

We'll look at how to involve our inner artist in the practicalities of painting (Chapter 1), deciding how to paint (Chapter 2) and what to paint (Chapter 3), painting (Chapter 4), caring for our creations (Chapter 5), and keeping an art log (Chapters 6 and 7). The guidance, encouragement and insights in *Free Your Inner Artist* draw heavily on wisdom passed down through the ages in the fields of philosophy, psychology, spirituality and art, and on my own experiences of learning, teaching, healing and painting.

Free Your Inner Artist will encourage you to be creative, discover your personal style and find which materials and methods suit you best. I very much hope it will also give you great joy.

Penny Stanway
October 2010

Chapter One – Practicalities

Painting gives pleasure to millions of people around the world. A lot more would love to paint but are put off by the practicalities involved, or some other stumbling block. This is frustrating because it means their inner artist remains shut away, at least in this sphere of artistic activity. As a result, they can't express their creativity through painting. At the same time, though, this pent-up well of creativity is potentially exciting because if artists-in-waiting can recognise what in particular puts them off, and then find solutions, they can untap originality, inspiration and imagination which could **benefit not only themselves but others too and even, perhaps, society as a whole**.

The most common stumbling block for would-be painters is the deep-rooted belief that they aren't – and never could be – good enough at art, or simply aren't 'artistic'. Other blocks include having too little time to paint or nowhere obvious to do it, and not knowing how or even *what* to paint. We'll focus on how to paint in Chapter Two, what to paint in

'Every child is an artist. The problem is how to remain an artist once we grow up.'
(Pablo Picasso; 1881-1973; artist)

***My Flower Book – 1 and 2**, 1954*
***Dandelion**, 1956*
***Twig in Leaf** (page 4), 1956*

If you have young children, it's a good idea to store their paintings somewhere safe. After all these years I'm still pleased that my parents (John and Joan Rench) took the trouble to squirrel mine away

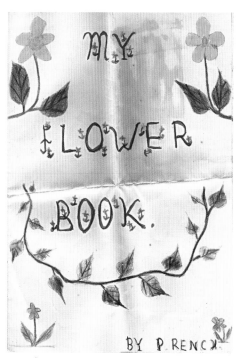

My Flower Book – 1, pencil and crayon on paper, 28x19cm (11x7.5in)

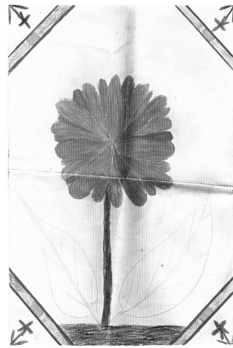

My Flower Book – 2, pencil and crayon on paper, 28x19cm (11x7.5in)

Penny Rench.

*Dandelion, watercolour on paper,
14x11cm (5½x4¼in)*

Chapter Three and on who, why,
when and where to paint, below.

If you really want to paint, your first
task is to try to discover which, if
any, of these barriers affects you and
then to focus on what might help.
This could free your inner artist and
may even change your life.

WHO CAN PAINT?

Everyone can paint

There is no one ideal age, stage or
personality type for being a painter.
Everybody is potentially an artist.
Indeed, being artistic is one of the
qualities that makes humans
different from other animals. You're
never too young or too old. All
young children take naturally to
being artists.

Sadly, many children begin to doubt
their ability as they grow up. They
learn to believe they are not artistic
and so become increasingly
reluctant to paint. If you always

thought – or were told – you were useless at art at school, it's easy never to bother again. And if a sibling or a friend gets 'A's' for art, it's extraordinarily easy to conclude – mistakenly – that they are artistic and you are not. In effect you assign the role of artist to them and write yourself out of the equation.

But while the fear of not being good enough is a big deterrent, don't let it stop you painting. It's really strange how readily we accept the notion that we should paint only if we are told by others that we are 'good' or 'talented' at it. We simply don't do this in other spheres of life. Many of us thoroughly enjoy cooking, singing or football, for example, even though we may not be particularly good at it. We get pleasure both from the activity and from its fruits – such as the taste of the food we have cooked and the adrenaline 'high' and the camaraderie of sport. Yet when it comes to painting we imagine we have to be adept and talented if we're so much as to pick up a brush. All too often this completely stops us from doing so.

This distorted logic has to stop because everyone, whatever their age or ability, can gain something from

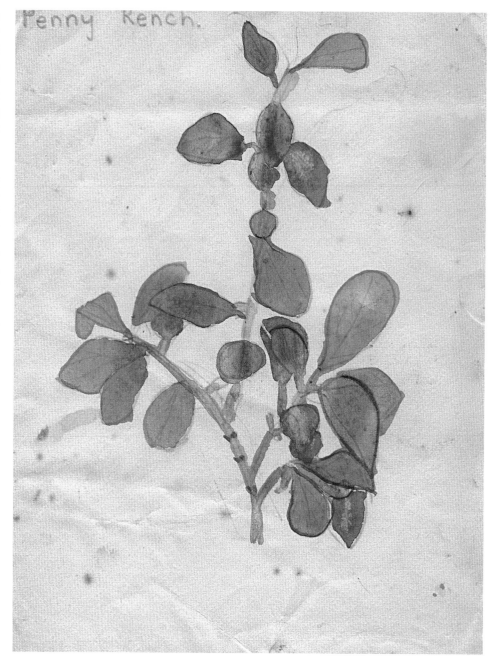

Twig in Leaf, watercolour on paper, 14x11cm (5½x4¼in)

painting. It's obviously an advantage to be talented, as it is in any field, but it certainly isn't a necessity. The world would arguably be a better place if more of us used and revealed our creativity.

Many people stop painting in childhood but take it up again later in life. It's never too late and the odds are you'll have more time once any children have flown the nest and when you've cut down on paid and unpaid work commitments. Novice artists can be any age – in fact, some experts believe older 'starters' produce some of the most interesting and exciting work. This stands to reason, because those who embark on painting in middle life or beyond have more experience of life than do younger people. If life has also made them more emotionally aware, this combination can create a very heady result, both for themselves and others.

> *'An artist cannot fail; it is a success to be one.'*
> (Charles Horton Cooley; 1864-1929; sociologist)

You don't even have to have many years ahead of you to enjoy painting or become a very able painter. Vincent van Gogh (1853-1890) painted for only ten years before his untimely death. While his genius was, to all intents and purposes, unrecognised during his lifetime, his brilliance is nowadays beyond dispute and his place in art history assured.

What about training?
Because so many people see painting and drawing as 'difficult', they imagine that they'll need some sort of tuition before they can even start. So is it worth considering a proper

Life Class at Bletchingley,
1, 2, 3, 4, 5, 1993

Depending on your commitments, you might have time to attend a drawing or painting class – like I did when my three children were teenagers

Life Class at Bletchingley
pencil on paper
picture 1: 59x41.5cm (23½x16½in)
picture 2: 41.5x59cm (16½x23½in)

art training? Some training is excellent, some good, some mediocre or even poor. It varies according to the quality of the institution, the syllabus and the teachers. Certainly, there's a great deal to be learnt about techniques and skill. However, art training is often surprisingly mechanical.

The truth is, though, that you don't have to go to classes of any kind to free your inner artist, though you might strike it lucky, as I did with my most recent teacher (see below). Many art courses don't consider creativity worthy of consideration, let alone encourage the exploration of whether a student's inner artist is free.

Another thing worth bearing in mind is that a great many evening art classes use watercolour paint. But while this has the advantage over oils of being quick and easy to clean up, it's a particularly challenging medium for a beginner. Without much experience the results are likely to be unsatisfactory, so many people become discouraged and give up. Acrylic paint (see Chapter Two) is much more forgiving and easy to use.

Life Class at Bletchingley
picture 3
pencil on paper
59x41.5cm (23½x16½in)

Many of the great artists throughout history have been, to some extent at least, self-taught, and many self-taught artists gain immense satisfaction from painting whether or not they ever achieve recognition or sell anything. So don't feel you have to attend classes.

What's most important is to keep on painting as much as possible and, when it comes to improving techniques, to learn from your mistakes as you go along.

What I've learned from teachers at various classes and workshops over the years has been different from each one, but one teacher, John Simpson, has been by far the best for me. He is my most recent teacher and the one I had during the years in which I wrote my art-class log (see Chapter Six). Without ever actually spelling them out, John taught me **two vitally important lessons**:

The first is to observe my paintings. Until then, I'd always expected a teacher to look at my work and say what needed to be done next. Even if I was secretly pleased with a picture, I'd expect adverse criticism rather than interest and constructive comment. Learning to look at my

Life Class at Bletchingley
pictures 4 and 5
pencil on paper
41.5x59cm (16½x23½in)

work carefully was a vital turning point. A good long look gives me time and space to 'own' my painting, maybe understand where it's coming from and, perhaps, recognise where it needs to go. Some teachers – often with the best of motives – suggest what to do only for this to ruin the work for ever in the eyes of the artist. The point is that when someone is painting with their inner artist, their subject and style are highly individual and important and may be coming directly – and 'untranslated' – from their unconscious. No outsider can say what should come next. If they do, they'll probably break the 'spell'. All in all, learning to look at my work myself – in a sense just to 'be' with it – is the best lesson I've had.

The second is that techniques and materials are there to be my servant, not my master. The teacher in question has a healthy disrespect for paint, paper and brushes. Adopting this point of view has completely deflated their perceived power so nowadays I'm never paralysed by fear or awe of materials and methods. (For more on this point, see page 39.)

> 'Never listen to anybody over responsibilty for your paintings. It's a mistake for young artists to want to please older ones. They'll make you take out of your paintings the very things that most characterise them as yours. Nobody knows better than you what you need to do.
> (Julian Schnabel, born 1951, artist and film-maker)

Together, these two realizations have led to an outpouring of creativity that has stayed with me for years. My inner artist fills my well of creative energy more effectively than ever before.

Each of us is unique and has different needs, experiences, personality and aspirations, so whether you will benefit from any particular teacher will be an individual matter for you to experiment with and decide.

But beware – some teaching is unhelpful and some teachers unwittingly deter their students from freeing their inner artist. Since starting to write this book I've heard countless stories from people whose teachers put them off art at school – or even as adults. I'm sure lots of brilliant teaching goes on in schools but such reports are shared less often. John Snow, an artist friend, described a scene at grammar school that is still vivid in his mind many years later. When he left the room on one occasion to go to the loo, his teacher stopped by his easel, picked up a brush and added 'corrections' to his painting in thick black paint. On his return, John discovered what had happened and was so angry he threw the jar of paint water at the teacher. This smashed in the sink and drenched the teacher in dirty water and broken glass!! John's inner

May the Road Rise to Greet You, 2001

Doing a quick pastel sketch is a good way of capturing the feel of a place. This one reminds me of the beauty of West Cork and the melancholy I always sense is imbued in the landscape

pastel on paper, 19.5x24.5cm (7½x9½in)

artist clearly didn't take well to the implied, uninvited and invasive criticism.

Many artists find it helpful to belong to a local art society. This will probably be full of like-minded people at all levels of ability, and will have a varied programme of activities, including demonstrations, group painting sessions, lectures and so on. One of the principal benefits is that one gets to see other people struggling with the same challenges that one faces oneself. So although there is no formal instruction, it's possible to learn by seeing the mistakes and triumphs of others and then comparing them with one's own efforts.

WHY SHOULD I PAINT?
The benefits of painting

Just as we can get pleasure, fitness and friendship from swimming without ever becoming a medal-winner, so too can we derive benefits from painting without ever becoming an acclaimed artist. Painting isn't a competition, or something you do primarily for the approval of others. Your aim is neither to beat your fellow artists nor to please your teacher, friends or partner. Rather, it is to release, and benefit from, your creativity.

Every one of us has an inner artist and allowing ourselves to use our creative energy to paint opens up the possibility of limitless **enjoyment** from the process. This can come not only from the colours and consistencies of the paint itself but also from the achievement, wonder

Pink Sunset with Trees, 2004

Looking at the shapes of these trees silhouetted on the horizon on a balmy evening makes me realize how much strength, stability and resilience they need to withstand the wind, heat and snow atop the North Downs in Surrey

watercolour on paper 22.5 x28.5cm (8¾x11¼in)

and satisfaction of producing a picture.

Being creative lets us produce paintings that **say something real and important** about ourselves and our experience in ways no one else can. Our awareness of the beauty, interest and mystery of our surroundings and our experience of life are ours alone. They can be replicated by no-one else and they inevitably influence our paintings. Making a uniquely personal mark can **give us a thrill and a sense of achievement and purpose** which can make life more meaningful.

Learning to observe our paintings as we create them encourages us to become **more observant of the world around us,** and this greater awareness can **enhance our curiosity, pleasure and energy**.

Another huge benefit of working with our inner artist is that being creative provides the opportunity to **express our feelings** via our painting. This comes about as the free flow of creative energy carries with it unfinished business in the form of suppressed, ignored or otherwise hidden feelings that we may not consciously recognize but which emerge via our creativity. This **release of feelings can be a great relief** if hiding them has, unconsciously, been weighing us down. Very often, the less I feel like painting, the better it is if I just get on and do it. This particularly

applies if I'm grumpy or upset. Making marks with paint almost always defuses emotional discomfort and frequently swings me into a state of peace, contentment and sometimes even excitement and euphoria. The emergence of previously repressed emotions can help to **overcome certain defensive behaviours** ('defences') such as overeating. Such behaviour probably began as the only possible way, at the time, of dulling fear, anger, sadness or other uncomfortable emotions. But the personal growth that comes from working with your inner artist encourages different responses and more constructive ways of managing feelings, to move us on from past hurts. So art can be **a therapy that cleanses the dross of unfinished business and brings restoration, recreation, calmness and healing**.

Expressing ourselves through painting can make us **more sensitive to our feelings and those of others**. This self- and other-awareness make us feel and appear more open and empathic, which encourages emotional **intimacy** in relationships. Expressing ourselves through being creative also lets us **learn about ourselves**.

When we release our emotions, they can **fuel and colour our painting in new and different ways**. Releasing feelings by freeing our inner artist encourages us to **use our intuitive and instinctive right brain** as well as our brain's rational and intellectual left side. This provides a better balance between the thinking and feeling parts of the brain, giving a more balanced approach to life and encouraging insights without having

Ploughed Field at Sunset, 2004

Most of us are lucky enough to see gazillions of beautiful images in our lifetime, and sketching is an excellent way of reminding ourselves of ones that give us special delight

pastel on paper, 23x29.5cm (9x11¾in)

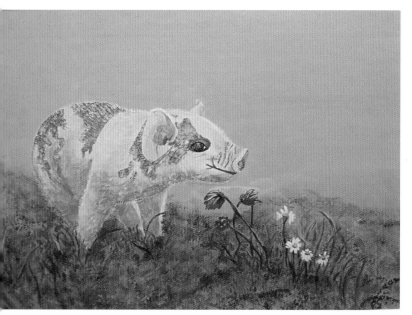

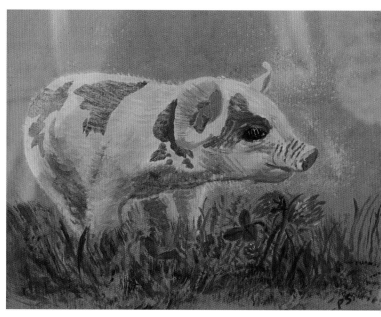

Piglet - 1, acrylic on board, 20x25cm (8x10in)

Piglet - 2, acrylic on board, 20x25cm (8x10in)

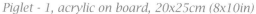

consciously to understand them. You may also notice **more symbolism in your painting,** as well as the emergence of long-forgotten but **emotionally important images** from your past.

Having said all this, it's important to point out that some artists simply don't need or want to express their emotions through their painting, because they have other ways of releasing, recognizing and using them. One artist friend says that if he wants to express sad or negative feelings, they usually surface as poetry, never as a painting.

Another possible consequence of freeing our creative energy is that we feel **warmer, happier, more energized and enthusiastic, even fired up,** both during a painting session and perhaps for the rest of the day.

We become active and inspired creators instead of passive and, perhaps, dull observers or consumers. The final bonus is that the spark, glow or fire of our new-found energy can make us feel **more at one with God** or with whatever is our concept of the creative power of the universe. My belief is that the

beauty, emotion, humour, mystery and wisdom in the world around us can sometimes resonate in our own creations. Many of us find it hard to discover our inner spirit and painting can come as a delightfully surprising key that unlocks a dulled heart or soul.

Part of the attraction of all this is that the process is non-verbal, or even 'pre-verbal'. We all become so used to talking all the time that we don't give our inner self the space to come out to play, or even to cry. Freeing our inner artist gives us this space in a way which is uniquely personal.

All of this is about how freeing our inner artist can benefit *us* ... but it may also benefit those who view our paintings, because creative work:

- Shows life from a different perspective, which **makes others stop and think, so influencing how they see and understand the world and even, perhaps, act within it**

- **May evoke strong emotion and a sense of magic or awe in others,** in ways that art that is only technically skilled may not

- Portrays images that have been formed in the crucible of the right side of the brain and polished with passion, so **may go some small way towards restoring the balance in the world between the predominant intellectual yet limited 'left-brain' activity of its inhabitants and the currently less unimportant intuitive and empathic 'knowing' of the**

Piglet – 1 and 2 (opposite), 2005

One of my daughters has one of these paintings, my sister has the other. Whenever I look at them during a visit, the obvious contentment of the piglets reminds me of when I was eight years old and used to play on the way home from school among mounds of long grass whose scent has for me forever since symbolized summer, freedom and happiness

'right brain'. This could just make the world a better place for us all and is why artistic and other creative work has enriched human cultures since time began.

One of the great benefits of the visual arts is that most of them are lasting, so their influence can echo down the generations.

To sum up, you don't have to be good at art, or consider yourself artistic, for your paintings to have truly amazing benefits.

WHEN CAN I PAINT?

There's always time
It's a common observation that busy people find time to fit in something extra. That's not to say that filling our day is necessarily wise, just that believing that we can't find time to paint might have more to do with our mindset than with reality. Whatever our challenges in life, if we really want to paint, it's well

> 'A striking balance of intellectual and emotional experience makes a great artwork.'
> (Tibor de Nagy; 1908-1993; gallerist)

worth thinking about out how to carve out even that occasional hour or so each week.

Prioritize
Try listing the things you do each day in order of importance, and jotting down how long each takes. Now see where painting could fit into this list. Some thoughtful prioritising and time planning could encourage you to delegate more or learn to say 'no' to things that you had previously considered essential.

Use a sketchbook and a notebook
Keep a notebook and pen or pencil handy so you can take a few minutes here and there to sketch each day. A quick drawing doesn't have to be perfect or complete. This sketchbook idea can work particularly well for parents of very young children – particularly working parents – and even grandparents! Perhaps instead of racing around trying to get things done when your baby is asleep, you

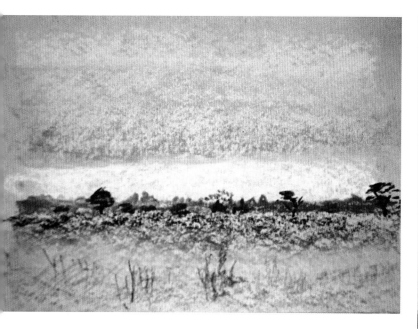

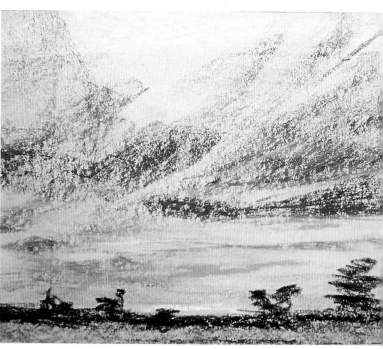

Blue Horizon, 1988
Sunset opposite Alderstead – 1 and 2, 1988

*Amazing sunsets are among the glories of Creation
and if you keep a sketchbook and some pastels
or crayons handy you can record ones like these
in just a few minutes each*

above: *Blue Horizon, pastel on paper, 19x24.5cm (7½x9¾in)*
top right: *Sunset opposite Alderstead – 1, pastel on paper,
19x24.5cm (7½x9¾in)*
right: *Sunset opposite Alderstead – 2, pastel on paper,
19x24.5cm (7½x9¾in)*

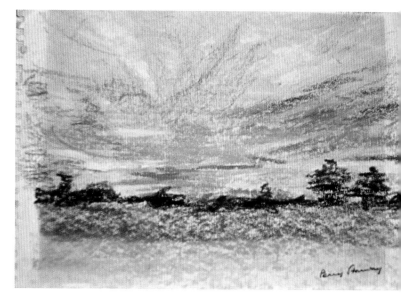

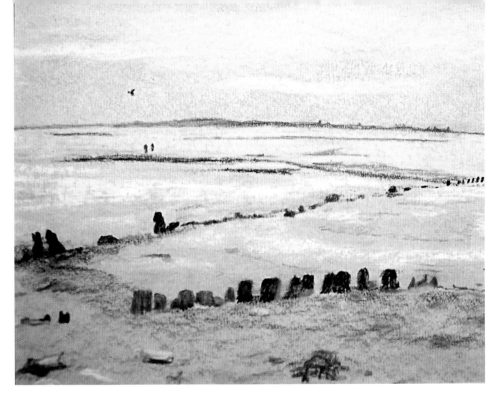

might sometimes get out your sketchbook and draw. Or if you have time during your lunch-break at work, sit outside or by a window and sketch the street or the passers-by.

Many artists and art teachers set great store by keeping a sketchbook on the go. This certainly means you can record attractive or interesting glimpses or otherwise easily forgotten ideas that you might later incorporate into a painting. Sketching acknowledges the existence of our inner artist and gives our creative energy the chance to flow. It also acknowledges that observing and recording the world around us is a vital step to becoming an artist. Remember, you don't have to record or recognize things in a photographic way. Your unique way of expressing what a tree, for example, looks like, is what separates art from photography. After all, this is what your inner

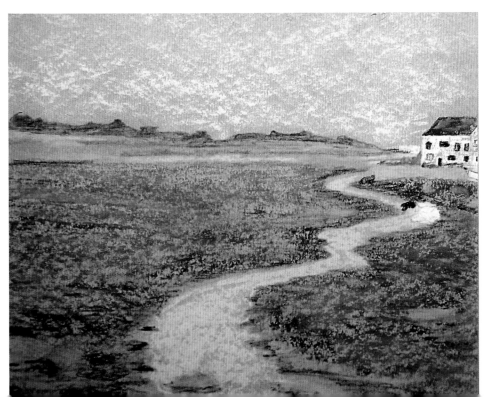

Bembridge Beach, *1988*
Bembridge Salt Marsh, *1988*

I sketched each of these on the spot. I could have used photos as sources but I believe I can smell the salty air and hear the seagulls' cries better from this work done 'en plein air'

Bembridge Beach, pastel on paper, 19x24.5cm (7½x9¾in)
Bembridge Salt Marsh, pastel on paper, 19x24.5cm (7½x9¾in)

artist is contributing to the world. No concert pianist believes that the final, definitive performance of a work has yet been recorded. We each bring uniqueness to our artistic expression, which is the main thing that makes it special.

You can also gain from keeping a notebook of ideas, dreams and stream-of-consciousness thinking, and spending a little time writing each day. Try to get into the habit of doing this for say a daily five or ten minutes at a set time. This might be first thing in the morning if you're a 'lark', or it might be late at night if you're an 'owl'.

Spontaneous sketching will help free your inner artist. If you are going through a particularly busy time and really have *no* time to paint, it will also remind you that you are creative at heart.

Arrange some 'me-time'

Another way of encouraging your inner artist is to make 'me-dates' in your diary for special times to refill your well of creativity. You might walk somewhere beautiful, edgy or interesting, or go to an art exhibition, a play or a concert. What you're searching for is anything that will delight or usefully disturb you … something you find magical or

Seascape near Oban, 1987
Tuscan Hills, 1987

Not only do these two sketches record two highly contrasting places – one experienced with family, the other with friends – but each acts as a switch that evokes very particular feelings and memories

below: *Seascape near Oban, pastel on paper, 19.5x24.5cm (7½x9½in)*
right: *Tuscan Hills, pastel on paper, 21x30cm (8¼x11¾in)*

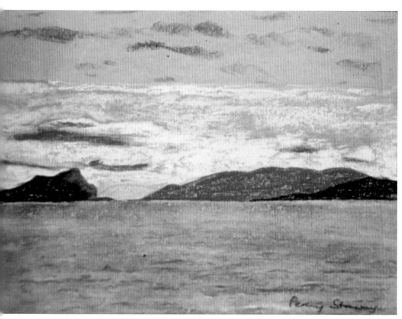

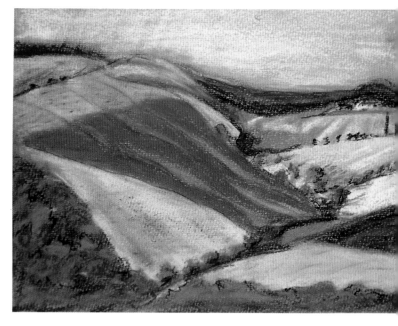

intriguing, or that will provide 'seed-corn' that will inspire fresh ideas and emotions for paintings. Creative people involve themselves in the 'creative world' for very good reasons.

WHERE SHOULD I PAINT?

The simple answer is that you can paint anywhere. But the reality is that some places are much more artist-friendly than others when it comes to such things as the potential to make a mess without ruining floors and furnishings, having enough space to store bulky equipment (paints, brushes, easel, paper, canvas, boards or other 'supports', and unfinished and finished artworks) and being physically and emotionally comfortable and at ease. Among the options are painting at home, at a friend's home, at an art class, at a rented studio, or outdoors.

Whatever your options, give yourself the best possible back-up, so the location is encouraging and supportive rather than a deterrent. If you intend to paint outdoors, think how you can most easily transport your equipment, which paints are most 'outdoor-friendly', and whether you need a collapsible chair and/or easel. If you are going to paint at home, think where you can most conveniently store equipment, where you can leave paintings to dry, and where you can work most comfortably and without interruption. Obviously it's brilliant if you can set up a dedicated studio or at least a room of your own that can double as a studio. But painting in a room such as the kitchen or sitting room can be

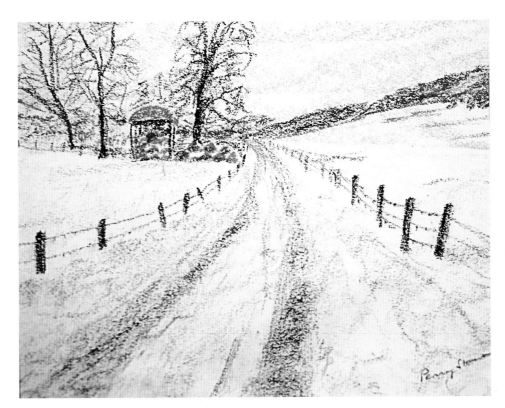

Woldingham School Drive, 1988

I did this sketch sitting in my car on a freezing winter's day on the way back from dropping the children off at school. My lap made an acceptable easel, my pastels were ready to hand and keeping the engine and windscreen wipers running kept me warm and the view clear

pastel on paper, 19 x24.5cm (7½x9¾in)

'When people are in touch with themselves, their physical postures change, creative energy emanates....'
(Michele Cassou and Stewart Cubley; artists and educators)

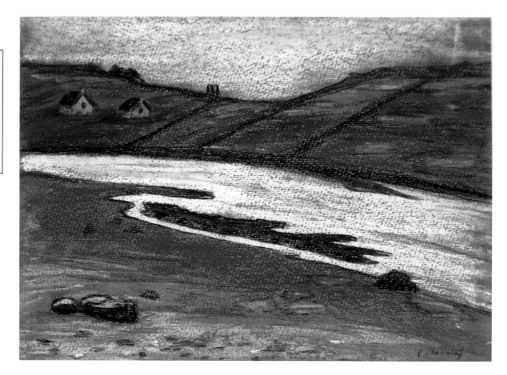

fine too, if you get yourself organized.

Wherever you paint, and whatever type of paint you use, you'll also need a suitable place to prepare your palette, and to clean and store both it and your brushes. Easy access to a sink is a bonus, though it's possible to get by without. On a recent visit to a large art studio complex (Wimbledon Art Studios, in south-west London), I was interested to see that 190 or so artists shared a very small number of sinks in the corridors outside their studios.

Worrying about messing up surfaces will interfere with your concen-

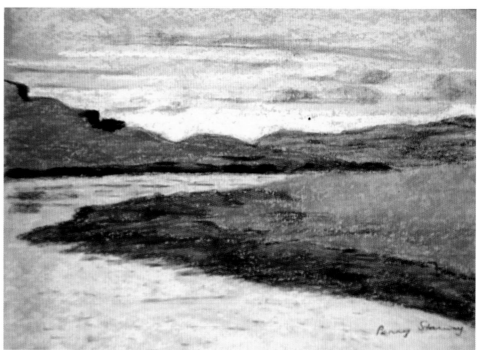

River Ilen - 1, 2 and 3, 2005

Taking a camping-chair to the strand and sketching with a just few pastels by my side made it easy for me to capture the silvery beauty of the river as I did these quick sketches before the tide came up to meet me

far left: River Ilen - 1, pastel on paper, 21x29.5cm (8¼x11½in)
far left, below: River Ilen - 2, pastel on paper, 21x29.5cm (8¼x11½in)
left: River Ilen - 3, pastel on paper, 21x29.5cm (8¼x11½in)

tration on painting. So unless you are lucky enough to have a studio space, where you really don't need to be concerned if you spill or flick paint, remember to protect the floor around you, as well as any surfaces on which you put paints, brushes, water pots, solvents, glazes, varnishes, primers and palette. Use newspaper or, for acrylic and other water-based paint that you can wipe up with a wet cloth, polythene sheeting or an oilcloth.

Time spent planning how best to use your venue is time well spent; even a small outlay on suitable equipment could make your space much more attractive to use.

Be comfortable

It's sensible to be as physically comfortable as possible when you paint, because practicalities such as stance, breathing, stress level, hunger, thirst, air temperature and quality, clothing and the presence or absence of other people all influence our ability to be creative. All kinds of discomfort can hamper the inner artist. This isn't to say that someone with ongoing discomfort can't be creative because they certainly can! But whatever our state of health it's worth taking as good care as possible of our physical needs during a painting session.

I prefer to stand when painting, because it gives me more creative and physical energy. I also feel free to swing my arms, and I can easily take a few steps back to look at my work from a distance – which I often find I want to do. It's when my creativity is flowing that I most want to move – even sometimes feeling as if my body is weightless. It's an extraordinary state of being.

If you like to stand at an easel, spread your weight equally between both feet. If you like to sit at a table or with a sketchpad on a cushion on your lap, keep your feet flat on the ground, your legs uncrossed, your back straight and your shoulders relaxed

and dropped so they are neither tense, nor hunched nor rounded. This will help prevent your joints and muscles from stiffening and aching.

Keep your physical energy level topped up by eating something nourishing at regular intervals. If you know you sometimes get so carried away during a session that the last thing on your mind is taking time off to cook a meal, prepare something in advance so you don't have to stop painting. Alternatively, you might be lucky enough to have someone else to look after you.

If you notice unexpected bodily symptoms or sensations while painting, consider what they might mean. States such as excitement or anxiety very often produce physical sensations (such as a feeling of heat) or symptoms (such as a rapid heartbeat, or light-headedness). This is well known. But it could also be that your unconscious is communicating a message via your body about a previously repressed emotion that is now coming to the surface. Your painting could be allowing this emotion out into the open, which is where it belongs.

Check that you have adequate heating and cooling facilities where you work, as there's little worse than feeling uncomfortably hot or cold. If you paint with oils, ensure there is enough ventilation to get rid of paint and solvent fumes; or treat yourself to water-soluble oil paints or the low-odour variety. Wear comfortable shoes and clothes, and protect your clothing with a smock, another type of overall or – if you habitually make very little mess – a wipe-down apron made from oil-cloth or a plasticized fabric.

Bronze Horse – 1 and 2, 2004

Drawing and painting alongside other people can be a most convivial experience. As I drew and also painted this horse from a model at my sister's house in mid Wales, I found her encouraging presence a great delight

right: *Horse – 1, pencil on paper, 12.5x18cm (4¾x7in)*
opposite: *Horse – 2, pencil on paper, 12.5x18cm (4¾x7in)*

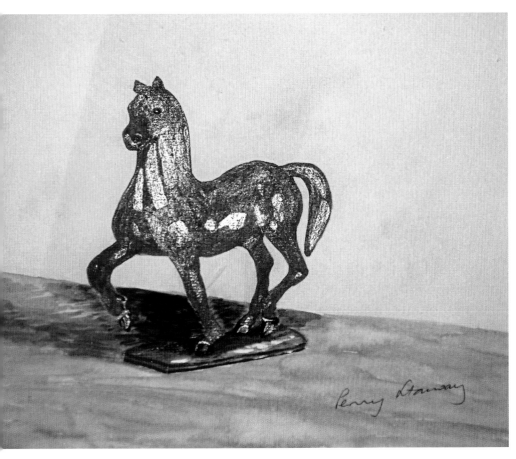

Finally, take note of whether you prefer to paint alone or with others. Your preference may change over time, but it's wise to be sensitive to your current need for solitude or company and to meet this if possible. Some people always prefer to paint alone and in silence, while others are happier with company and music or other sounds.

The *feng shui* of your surroundings
Just as important as the practicalities of your place is its feel, design, layout and position – known to some as its *feng shui* (pronounced 'fung shway'). This is an ancient Chinese system of aesthetics based on astronomy and geography and believed to improve life by influencing a location's energy flow (*qi*). Everyone intrinsically feels that some places are more pleasant, comfortable and 'right' feeling than others, regardless of their size or the expense or taste of the decor.

However propitious or otherwise your space, you can influence how you feel in it. Try positioning yourself in different places with respect to the door and windows, to see which feels best to you. Some people prefer not to have their back to a door; others like to be able to look out of a window. If you have an easel, try it in different areas of the room. Check that the lighting is as good as possible. You might want to fit a full-spectrum light tube if the

windows are small or you often paint after dark. This is a type of fluorescent tube that produces bright light of a similar spectrum to that of sunlight. A 'daylight' tube is not the same as a full-spectrum one. The practicalities of your workplace, such as whether you can easily reach your paints, are obviously important too. And if you have your own room you may like to personalize it in some way – perhaps by choosing the colours of the walls and blinds.

Getting the *feng shui* right can be a great encouragement to creativity.

Easel, table, floor or lap?

I've painted or drawn at various times with my paper or other support resting on newspaper on a table or on the floor, on a board on my lap, on a drafting table, on a tabletop or floor-standing easel, or on a large pinboard fixed to the wall. There are pros and cons to each. What's best for you is whichever one you like best and feel most at ease with, and whichever is most appropriate for what you are doing, the support and tools you are using, and the size and type of the work. Very fine work might be easier to do sitting at a table, while large-scale abstract expressive work is best supported on a floor-standing easel, or fastened to, or propped against, a wall. Experiment to discover what you prefer.

If you're thinking of getting a floor-standing easel, try one first at an art class or art shop. You can then purchase one either from a shop or on-line. Or you could ask whether someone you know could make you an easel. Or you could make one yourself. You'll find instructions at http://www.wikihow.com/Make-an-Easel

I remember telling a fellow art-class student that I'd like an easel but imagined it would cost a lot of money. He immediately drew me a diagram of how to make one, which gave me a sense of childlike delight. His simple drawing defused the off-putting mystique I'd built up around the subject of easels, thinking that they were for 'proper' artists, not for me. I subsequently went online to look at easels and discovered they weren't as expensive as I'd feared. Now I'm the proud owner of two floor-standing easels and a handy table-top one. They suit me well and please me every time I use them.

Don't forget you can chop and change, sometimes painting at an easel and sometimes at a table. There are no rules.

Include a mirror

Having a large mirror available so you can put a painting in front of it can help you see a painting afresh and pinpoint what's needed to enhance it. When a painting is the wrong way round it tricks the eye and can even make us feel we are seeing it for the first time.

Another way of doing this is to place the painting on the floor, with its base standing against a wall, then to face away from it and, bending right over and with your feet apart, view it 'upside down' through your legs.

It's arguably more important to choose what to paint first, then how to paint it. But we'll do it the other way around, given that you'll need materials at the ready before you start a painting. So we'll consider how to paint next, then what to paint in the following chapter.

Chapter Two – How to Paint

All sorts of questions rear their head when a would-be painter considers starting out. Some concern the choice of art materials; others, how to use them. What's vitally important to know is that an artist's familiarity and expertise with materials is relatively unimportant compared with the creative input into their work. Creativity is a function of the freedom of your inner artist, not of your technical ability or knowledge of materials. Artists – and especially 'starter' artists – do themselves a huge favour by letting themselves experiment, invent and play with art equipment. This brings release and fulfilment rather than anxiety and fear. When you've found a creative niche that delights and challenges you, you may indeed want, or need, to study technique, because improving it will certainly produce more satisfying results. There are many books about art techniques. Here, though, we'll simply look at some very basic matters.

CHOOSING MATERIALS

Many starter artists are confused by the plethora of art materials. Some, indeed, are completely put off and their creative urge becomes deflated. My aims here are to debunk some of the mystique and to help you discover what's best for you, so you know what to look for when you go into an art supplies shop.

House – 1, 2, 3, 1952

Like many young children I enjoyed doing pictures of houses. The horizontal flowers by the path and the lack of perspective in the path and the garden walls are typical of early childhood paintings

left: *House – 1, pencil on paper, 14x12.5cm (5½x5in)*
middle: *House – 2, pencil on paper, 14x12.5cm (5½x5in)*
below: *House – 3, pencil on paper, 14x12.5cm (5½x5in)*

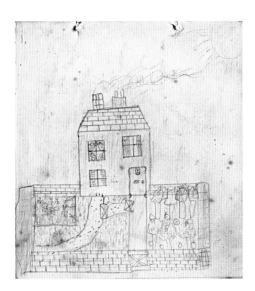

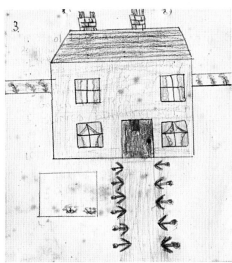

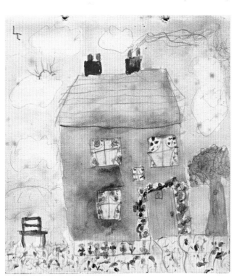

Bare Tree at Sunset, 1986

When I did this sketch I was a busy writer and mother of three, and soft pastel was quick and easy to use in a short island of time. The colour black seemed appropriate for the skeleton of this windswept tree as it reflected some of my grief following seven deaths in our family

pastel on paper, 19.5x24.5cm (7½x9½in)

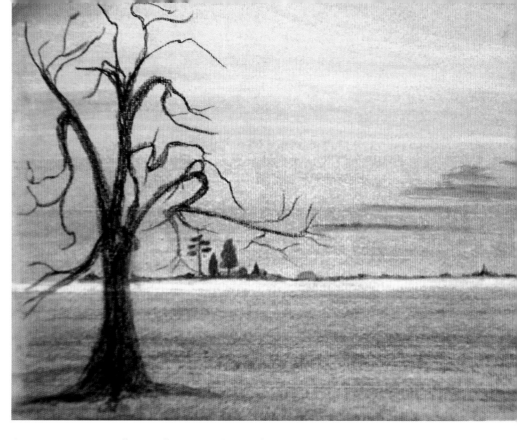

'It is not because things are difficult that we do not dare. It is because we do not dare that things are difficult.'
(Seneca; 5BC-65AD; philosopher, dramatist, politician)

On entering such a shop, we're confronted by many ranges of different qualities and prices of oil paints, acrylic paints, watercolour paints, gouache, poster paints, inks, crayons and other media. Each range includes many colours. Then there are all sorts and sizes of paper, board and canvas. Paper may or may not be stretched, boards may or may not have a backing frame, and canvases may or may not be stretched on a backing frame. As for brushes, there are as many shapes and sizes of bristles, lengths and sizes of handles, and qualities, prices and types of fibre and handle as you can think of.

If you're equipping from scratch, you'll need to decide on the sort of paint, whether to buy paper, board or canvas, what size this support should be, and which type and how many brushes to get. It's normal to be unsure what's best when first embarking on painting, as with any new activity, so don't let any feelings of fear, ignorance or helplessness put you off.

There are many sources of help and advice, including the art-shop staff, your teacher or fellow students if you attend art classes, the internet, and books on how to paint. Folk wisdom has it that a 'teacher' always

appears in some guise or other when we most need one – and in my experience this is true.

Your choices are likely to be influenced by cost. And you'll probably have other views about what to buy, based perhaps on times when you've painted before, or the types of painting you like to look at. The exercise in the adjacent box involves imagining that you are painting and may help you decide.

Imagine yourself painting

Sit in a quiet calm place, relax, close your eyes, and imagine you are painting. See which support, paint and brushes your mind's eye selects for you. This may provide you with instinctive answers to which materials will suit you best.

When I do this, I think of myself painting an enormous canvas with colours that are dark and light, rich and vivid, and using large, long-handled brushes that have an amazing combination of stiffness and suppleness. In my imagination I feel free and easy, as if I can fly.

Now let's consider some of the implications of your choice of paint media, supports and brushes.

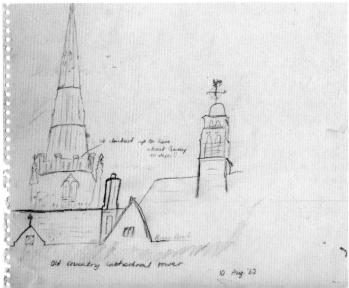

Electric Tree, 1989
Old Coventry Cathedral, 1962

Several decades separate the sketches of Coventry Cathedral and the imaginary fibre-optic tree, but pencil remains an attractive choice of medium for me

left: *Electric Tree, pencil and crayon on paper, 30.5x23cm (12x9in)*
below: *Old Coventry Cathedral, pencil on paper, 45x80cm (17¾x31½in)*

Fiona, 1959

As a teenager I did this outline portrait of my best friend with poster paint – a standard school-art watercolour paint containing pigment bound with gum or other glutinous material and made opaque with chalk or other whitening

poster paint on paper 53x38cm (20¾x15in)

SELECTING PAINT

We'll consider three types of 'paint' – acrylic, oil and watercolour – plus soft pastel sticks.

Acrylic paint contains pigments bound with an emulsion of water and acrylic polymer resin. It never goes yellow, mouldy or brittle.

Oil paint contains pigments combined with linseed or other 'drying' oil (which gradually dries in the air) and, perhaps, plasticizers and wax (to improve texture and help prevent cracking), drying agents (to aid drying), and stablisers (to prevent the pigment separating out).

Watercolour paint contains pigments bound with gum-arabic solution (which enables lots of water to be added to make washes), glycerine (to prevent cracking) and a wetting agent such as ox gall (to improve flow).

Pastel sticks are made from pigments combined with a filler of clay or whiting (chalk that's been purified, ground with water and dried).

Things to consider when choosing the type of paint that's most appropriate for you include:

- How fast you want it to dry: oil paint can take days or weeks, depending on the particular pigment and oil

- Whether you mind the smell of the volatile compounds from oil paint and its solvent. Standard paint smells of its oil; turpentine substitute or other solvent has its own strong smell. Water-soluble oil paints and low-odour solvents are available but are more expensive

- Whether you want the paint to be relatively transparent or relatively opaque. Many oil and acrylic paints are virtually opaque if they are used thickly enough, or if enough layers are applied, whereas watercolour paints can be used in transparent 'washes', and pastel sticks give a semi-transparent effect if applied lightly and on paper that has a 'tooth' (a rough surface)

- How important it is to you that the paint is easy to clean off hands, palette, brushes, solvent container and – though this will vary according to how messy or exuberant you are – the floor and other areas around you. Acrylic and other water-based paints are much easier to clean up than oil paints, which, depending on your work space, could be important. Pastel powder is the easiest of all to clean up

- Whether to choose 'artist' or 'student' grade paint. Artist grade contains more pigment and less

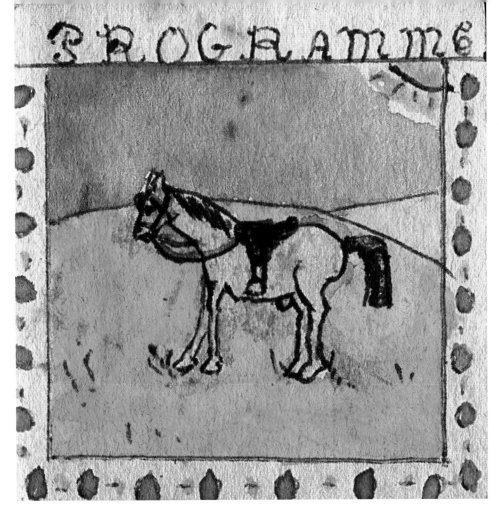

filler, so goes further. And not all student grade paints are light-fast, so in time some fade. However, student grade paint is considerably cheaper.

There's no right or wrong in your choice of paint – what's important is what best suits you, your available time, your personality, and your way of working. Finding the medium that's most suitable for you will help you focus on your painting rather than on any irritation or disappointment with the type of paint you're using. Your inner artist won't want to be impeded by an unsuitable paint choice!

PAINT QUALITIES				
	oil paint	acrylic	watercolour	pastel
Fast drying?	no	yes	yes	yes
Smell?	yes	no	no	no
Transparent?	can be	can be	yes	sort of
Opaque?	can be	can be	no	yes
Easy to clean up?	no	yes	yes	yes

Gymkhana Programme, 1954

One of my father's ballpoint pens plus my prized metal paintbox of watercolour pans set me up, as a horse-mad young girl, to create programmes for one of the imaginary gymkhanas I used to organise

biro and watercolour on card 6.5x6.5cm (2½x2½in)

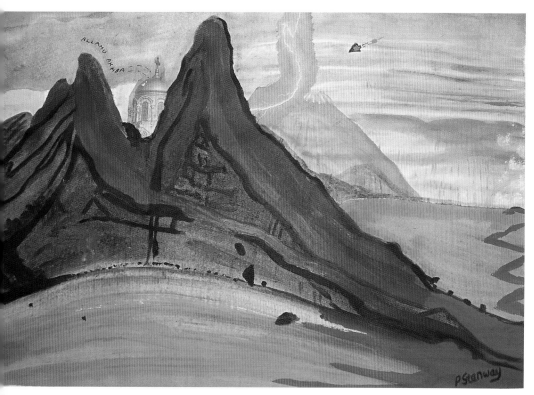

Rivers of Blood, 2009

Acrylic paint was perfect for this imagination-led and emotion-filled depiction of a hot volcanic desert area. There's no way I would have used oil paint and put up with waiting days for each layer to dry for such a spontaneous painting

acrylic plus paper collage on paper 28x40cm (11x15¾in)

If you're undecided, it may help to put a 'yes' or a 'no' in each of the spaces in the 'What's important to you' box below, then to refer back to the 'Paint qualities' box (see previous page) to see which sort of paint might suit you best.

Personally, acrylic paints have always been my preferred choice, because they dry much more quickly than oils, and I very much dislike the smell of oil paint and its solvents. I also like the fact that I can apply acrylic paint either thickly so it's opaque and produces a lovely impasto effect, or thinly so it produces a transparent effect or even washes like those of watercolour. Perhaps most of all, I like being able to clean up quickly and easily. While I love the romantic idea of a messy, paint-smeared studio, the reality of my personality is that I prefer neatness and order.

WHAT'S IMPORTANT TO YOU		
	important	not important
Fast drying		
Smell		
Transparent		
Opaque		
Easy to clean up		

SELECTING COLOURS

When visiting an art supplies shop it's easy for a starter artist to be dazzled by the wondrous choice of colours of their chosen type of paint, and seduced into buying more than necessary. The fact is you need only a small selection to be able to mix a great many other colours, plus their tints (made with oil or acrylic paints by lightening a colour with white, and with watercolour by adding water) and shades (made by darkening a colour with black). Books on art technique explain what colours to buy as a starter set, but a good basic selection is two of each primary colour – two reds, two yellows and two blues – plus white and black. By mixing these you can create the 'complementary' colours orange, green and violet (see page 42), plus greys, browns and a myriad of variations of each colour, including their tints (made by adding white), tones (made by adding grey) and shades (made by adding black). However, I always love to have lots of tubes of different colours at the ready, so I indulge myself by buying a wide variety. I include deep violet, because it's difficult to produce a good clear violet colour by mixing red and blue.

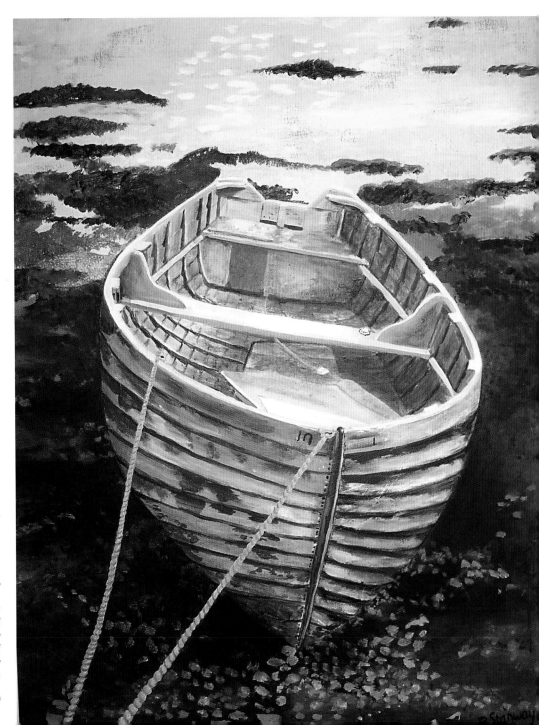

Boat at Baltimore Strand, 2007

Acrylic paint applied with brushes and a natural sponge and finished with fingers gave a particularly attractive texture to the weathered boards of this old boat near our Irish home

acrylic on board, 80x60cm (31½x23½)

When choosing your reds, blues and yellows, be guided by their warmth and coolness and consider choosing one warmer and one cooler version of each colour (see opposite).

Be guided too by your response to each colour, so you include in your choice colours that you love, or that excite you in some way. I always love painting with alizarin crimson, phthalo blue (green shade) and lemon yellow, so I make sure I always have plenty of these colours.

SELECTING SUPPORTS

Different people like painting on different sorts of support. My favourites are board (particularly 10-15mm thick marine ply), wood panels, and thick, rough, water-colour paper. I especially like to follow the lines and swirls of the grain in a plywood board with my brush and incorporate these into my painting. I'm not keen on the slight 'give' of painting on canvas. However, at some stage I would like to try painting on canvas (or a finer-

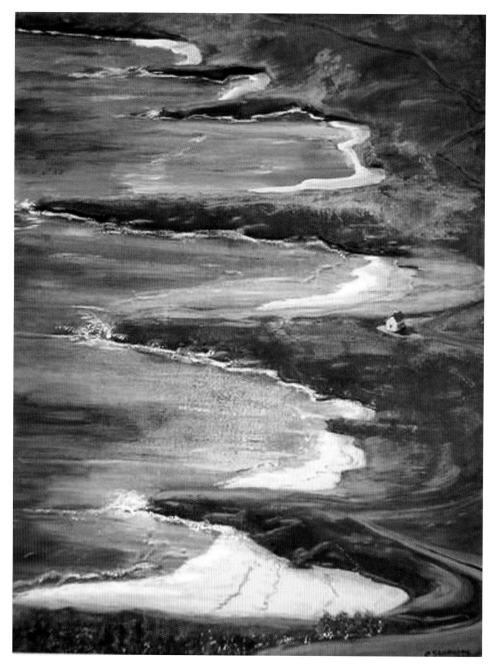

Peninsulas, 2006

Following one of the lines in the plywood grain of a new board made me think of the peninsulas and coves of south-west Ireland. The emerald-turquoise sea, the strands, waves and winding road then added sunshine and movement

acrylic on board, 80x61cm (31½x24in)

textured fabric such as linen) glued to board. Choose the support that you think will suit you and your needs best.

Hardboard, MDF (medium density fibre-board), wood panels, and plywood thinner than 10mm thick, will warp in time unless supported at the back with struts around the perimeter and, if necessary, as cross-bracers too.

Canvas needs to be fixed to a strainer frame (which you can't adjust) or a stretcher frame (which has joints you can adjust to tighten the canvas). Canvas comes in different grades of texture; in rolls or pre-fixed to a strainer or stretcher frame; and primed or unprimed.

It's important to seal supports, other than paper for water-colours. Sealing reduces absorbency, which in turn allows paint to spread more easily, so saving money! It prevents the oil in oil paint rotting the support. It stops chemicals in wood from leaching out and dulling overlying paint. It also encourages good adhesion and the easy application of paint. And you may want some of the whiteness or colour of certain types of sealant to show through the overlying paint.

The choice of products for sealing can be confusing but options for acrylic painters are either acrylic-

Ploughed Hills at Sunset, 2004

Soft pastels are perfect for recording images that take your fancy, but it's worth spraying finished work with a transparent fixative so it keeps its colour and doesn't shed loose pastel powder over the years

pastel on paper, 23x34cm (9x13¼in)

WARM AND COOL CHOICES		
	warm	cool
Blue	ultramarine	cerulean blue
Red	cadmium red	alizarin crimson
Yellow	cadmium yellow	lemon yellow

resin-dispersion size followed by acrylic 'gesso' primer, or acrylic 'gesso' primer alone. And for oil painters, either acrylic 'gesso' primer alone, or the sort of oil primer that doesn't need underlying size, or acrylic-resin-dispersion size followed by oil primer (see page 44).

Then, for a fairly cheap way of applying a coat of coloured paint, an acrylic painter could use a house-hold emulsion paint, while oil painters could use a household oil-based primer paint.

If using plywood or MDF, coat the front and sides of the support before you start your actual painting; for MDF, coat the back as well.

Machine-made paper comes in a choice of three surfaces – rough, hot-pressed, and cold-pressed.

- Rough paper has a texture with a prominent 'tooth'. Painting on this gives a grainy effect as tiny pools of paint collect in the indentations

- Hot-pressed paper has a smooth texture, so it's easy to apply large even washes of colour, and the paint dries quickly

- Cold-pressed paper (traditionally known as 'NOT', because it's *not* hot-pressed) has a texture between that of rough and hot-pressed papers, and is the most popular sort with watercolour artists.

Paper thickness is indicated by its weight in grams per square metre (gsm). Paper for oil painting should be at least 300gsm. If you use paper lighter than 200gsm for water-colours, either stretch it yourself to prevent buckling or buy it pre-stretched. Some artists prefer paper heavier than 200gsm to be stretched too, and unless it's 356gsm or more this is essential if their paint is going to soak the paper. An alternative is to glue paper to heavy-duty mount-board; even paper as light as 140gsm won't buckle then.

To stretch paper, cut four strips of gummed brown paper tape (sealing tape) slightly longer than the top, bottom and sides of the paper you're to paint on. Soak the paper in cold water for two minutes to expand its fibres (soaking for any longer, or in hot water, could remove its factory coating of size and make it too absorbent). Lift the paper from the water and gently shake off the excess water. Put it on a drawing board and smooth it with a sponge. Moisten one of the strips of gummed tape and stick it firmly along one side so one third is on the paper and two-thirds on the board. Tape the other sides of the paper, leave to dry for several hours, then paint on it with the tape *in situ*. Carefully peel the tape from the finished painting, or cut it off or hide it under a mount.

Choose acid-free paper for any paintings you might want to keep, because this yellows less with age.

You'll find many different sizes of ready-made support on sale, or you can buy large sheets of paper or board and cut your own (or have board cut at a builders' supplier), or buy canvas off a roll or in a roll. Most readily available art-shop supports come in standard sizes that have been popular for decades, if not centuries, but there is no reason not to do your own thing and make the support any size or, indeed, any shape that you want. Try out different dimensions and note which you feel most comfortable working with. Some people prefer to work small, while others, like me, like nothing better than to have a large, or even a vast, area on which to apply paint.

The choice will be governed by your personality, the subject matter, your painting style and your available time and budget. Storage facilities and the destination of the finished artwork are clearly important too. If you're happy with the size of support you've chosen, you're likely to be able to make better use of your creativity. This said, don't forget that you can overpaint a support, so if you're unhappy with the first thing you do, you may not need to throw it away. This is especially true of boards and canvases. Paper is less hardy and therefore more difficult to rework.

SELECTING BRUSHES

There's something of a mystique about brushes that can be very off-putting to a starter artist. All I would suggest is that you try painting with brushes with differently-shaped bristles, so you learn which brushes most easily make which sort of marks. Most important is to select a larger brush than you think you'll need. Beginner artists often use brushes that are too small then wonder why they aren't satisfied. Try putting away the brush you first pick out when beginning a painting and swapping it for a very much larger one. This is because it's often true that the bigger the brush, the braver it's possible to be with the paint and the less fiddly it is to work with the materials. It's also good because it stops you getting too detailed and fussy when you really should be getting cracking on the 'bigger

Harvest Festival, 1955

This poster-painted picture I did as a young schoolgirl was stored in a cardboard box for decades before seeing the light of day again. The paper and the colours have certainly stood the test of time!

poster paint on paper
22.9x30.5cm (9x12in)

 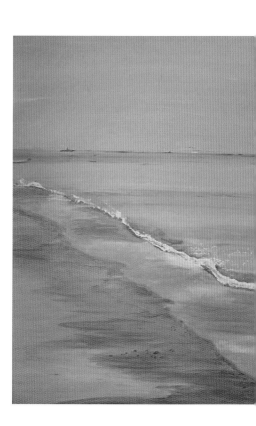

Shell Bay, near Studland – stages 1, 2 and 3, *2006*

I used huge flat brushes to map in the main areas of colour on this large board. Medium-sized brushes enabled me to add in the wave-crest and the wet sand, while a smaller one suggested ships and land in the distance

acrylic on board, 81x60cm (32x23¾in)

picture'. More novice artists founder on this rock than on any other. When starting off, the chances of your picture of a robin, for example, being the finest you've ever seen, are remote. If your drive to produce a picture of a perfect robin inhibits you, remind yourself you can always hone your efforts later or maybe take photos instead. Just for now go with the flow of your take on 'robin-ness' and see where it leads you.

It's also important to like the brushes you work with, so hold any brush you're thinking of buying and assess how it feels in your hand so you can decide whether this is one you'd like to work with. You'll probably discover that you quickly develop favourites among your collection of brushes. My favourites, and the ones I use most of the time, are large filbert-shaped ones of size 22 or above.

My experience is that although I have accumulated a very large selection of sizes and shapes of brush, I actually use only a very few. If I were starting afresh, I would buy only a few shapes, and each of these in only a few sizes. But I would also buy several of each particular one so I could change colours without having to clean my brush.

TOOLS - YOUR SERVANT, NOT YOUR MASTER

Most artists, myself included, experience a real sense of fear and apprehension on taking up painting in adult life. The clean white canvas or paper, or the pristine board, stares at you in threatening expectation. The brushes lie there neat, clean and waiting even though you don't have a clue which to use. And the paint looks too perfect to disturb in its tubes or trays. Out of this 'order' it can be hard to create 'chaos' when you're starting off. The individual with a tidy, meticulous or obsessional personality can find all this especially daunting. Perhaps

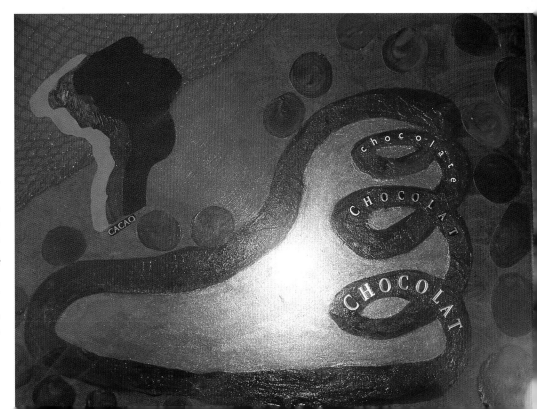

Chocolat, 2004

Sometimes – often, to be precise – I just play with my materials, perhaps using mixed media and experimenting to my heart's content. In this picture I aimed to give a sense of the rich brown smoothness and 'gloopiness' of chocolate, as well as its derivation and value

acrylic and collage on board 300x40cm (11¾x15¾in)

they were raised not to be 'messy'. Yet both paint and painting are potentially messy. This can be a real hurdle to jump.

Some wise instruction by one of my art teachers helped me overcome my nerves. In essence, he taught me not to be afraid of the support, paints, brushes and other 'stuff', but to think of them as my servant rather than my master (see Chapter Five). For example, at the beginning of one class he suggested going outside to collect twigs and handfuls of grass to paint with instead of using the art-class brushes. The marks I made with these were a quantum leap different from those produced with a brush. This experience completely removed any off-putting reverence I'd prev-iously felt towards brushes. Another time he supplied old poster paint that children had used in an art class that afternoon. The various colours were contaminated with other colours and the paint was thick and 'gloopy'. Yet my initial frustration and disappointment were soon tem-pered by delight at the astonishingly beautiful marks this paint produced. It was a surprise I'd never have had if the materials had been sterile and perfect.

The inner artist doesn't need fabulous quality materials (though they can be a welcome bonus). Your inner artist's creative energy can enable you to make enchanting or powerful images however mediocre or unexpected your tools.

NOTE TECHNIQUES THAT SEEM IMPORTANT TO YOU

It's shockingly easy to feel so ignorant about technique that you're put off painting altogether. For several years I devoured books about painting and artists but didn't once pick up a paintbrush myself. The vast bulk of available information about art led a little voice inside to tell me that I didn't have and, indeed, would never have, enough expertise. What a tragedy, looking back, to have wasted so much painting time. There's no way you need to *know* about art in order to gain experience, wisdom and enjoyment from doing it.

> 'There is only so much that can be said about painting. Painting is a **doing** thing.'
> (John Yardley; born 1942; watercolourist)

What's much more useful than cramming facts is to practice as an artist and pick up any tips that come your way and seem important to you. Writing down and keeping these personalized titbits will help you remember them. Here are some I've garnered over the years:

LIGHT AND SHADE, AND COLOUR

Working with light and shade is vital if your painting is to be interesting and memorable, not to mention arresting and captivating.

- Magnify light and shade to make a picture more vibrant. The artist Michelangelo Merisi da Caravaggio (1571–1610) gained fame with *chiaroscuro*, a technique that exaggerates the contrast between light and dark

- Squint at your picture, or at the scene or subject you are copying, to see the light and dark areas more clearly

- Paint shadows in a colour complementary (see page 42) to the main colour in your painting

- Or be guided by Matisse (1869-1954), or Pierre-Auguste Renoir (1841-1919), both of whom often depicted shadows in blue.

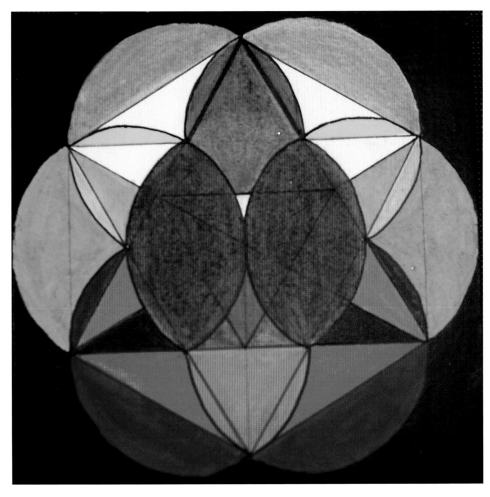

Mandala, 2006

This represents to me three levels of being – spiritual awareness (blue), everyday consciousness (green) and a deeper emotional level (red). Some people, myself included, experience synaesthesia, in which musical notes, or days of the week, for example, assume particular colours in the mind's eye

poster paint on board, 14x14cm (5½x5½in)

The presence of light and shade in a painting shows you are sensitive to the myriad nuances of light and darkness around you. If you find yourself reluctant or unable to portray much lightness or darkness, it's just possible you might be repressing emotions that are hard to bear, so it's worth taking time to listen empathically to yourself (see page 66) or, perhaps, to let some-one else do so.

Being aware of our emotions as we paint may enlarge our likely choice of colours and our use and degree of contrast of light and shade. This can lend our work vibrancy and brightness as well as darkness and shadows.

The awareness of emotions may also encourage us to include symbols. An artist out of touch with challenging emotions may paint pictures in pale pink and other pastel tints, perhaps because these colours somehow feel safe to them. Conversely, an artist out of touch with their gentler emotions and love of life may use

only dark, harsh colours and ignore the lights and brights. Alternatively, though, a palette that's limited in its range of colour or tone may be exactly what's needed. What's most important is to use the colours that call out and, perhaps, 'sing' to your heart, whether or not your head – or any other critic - tells you they are 'right'. So use what is right for you now, in the moment.

Here are some tips about colour that I've found particularly useful:

- **Exaggerate** colour

- **Different hues** of a colour adjacent to each other increase their intensity

- One colour for several areas gives **unity**; too many colours cause chaos

- Distant things are **paler, cooler, bluer, duller, blurrier**

- Nearby things are **darker, warmer, brighter, sharper**

- Try using a **colour wheel** – a diagrammatic device that offers guidance on colour combinations and colour mixing. The traditional wheel has red, yellow and blue as the **primary** colours, with the opposite (**complementary**) colours being green, violet and orange. The newer wheel (based on a slightly different colour theory and different pigments) has magenta, yellow and cyan as the primaries, and green, blue-violet and red-orange as the complementaries. (Remember, though, that our eye and our gut feeling are sometimes much better than a colour wheel at suggesting appropriate or exciting colour combinations.) Intensify and enhance a **primary** colour by putting its **complementary** by it, and vice versa. John Constable (1776-1837) and Eugène Delacroix (1798-1863) intensified greens with touches of red nearby

- Alternatively, intensify a primary by putting its 'split complementary' (the colour either side of its complementary) next to it

- Create the effect of the complementary by its primary, with **dots or dashes** of the other two primaries; for example, alongside red, put dots or dashes of blue and yellow, which together give the visual impression of green

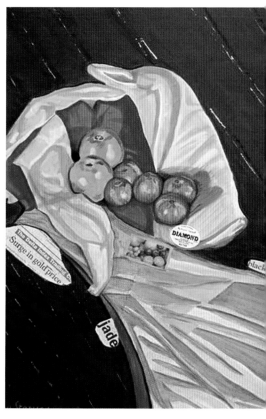

Precious Fruits, 2003

Complementary red and green, violet and yellow, and blue and orange lend this image particular vibrancy

acrylic and collage on board 61x45cm (24x17¾in)

- Decide which colour will predominate in a painting, then use its complementary as a primer and **leave some showing through**

- Very few shadows are actually black; try using complementaries instead. Delacroix used **violet and green shadows** by yellow and red objects

- Make near-**blacks** by mixing colours together

- Make **greys** by mixing colours, rather than mixing black and white

- Mixing **black and yellow** makes green

- Darkening a colour with black or brown tends to **deaden** it

- Convey **sunshine** by painting with white, then over-painting with yellow or orange

- When mixing a **pale colour**, add coloured paint to white, not vice versa

- My favourite colour combinations give me great pleasure and sometimes a **visual 'bounce'**.

They are: apple green and cornflower blue; royal blue and turquoise; lime and grey-green; orange and hot pink; purple and orange

- **Scumbling** is a technique in which one colour is applied loosely over another so some of the first shows through. Try scumbling with a complementary over its primary (for 'oomph'); a cool colour over a hot one and vice versa (to cool or warm it); white over black (for an impression of blue); and crimson over blue (for a violet effect)

- **Glazing** modifies a colour by washing it with a transparent glaze of another colour (though not an opaque one like a cadmium colour, or yellow ochre). Glazing produces a different effect from simply mixing the two colours. For example, painting a blue glaze over yellow gives a livelier green than you get with pre-mixed blue and yellow. As far back as the 15th century, Rogier van der Weyden (1399-1464) made a vibrant red from a thin red glaze over pink

- Don't be afraid to be bold and experimental with colour.

Pirate Ship, 2005

The darkness of this ship, with its black hull and sails set against the light, conveys a real sense of menace

ink on paper, 59x42cm (23¼x16½in)

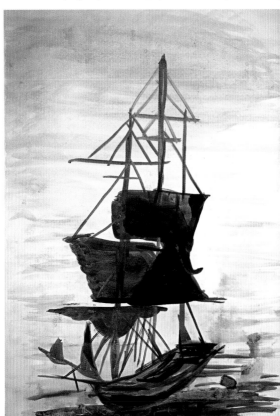

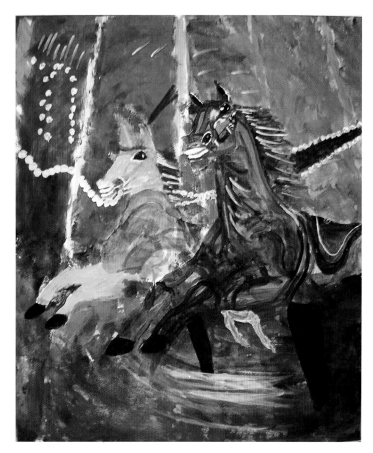

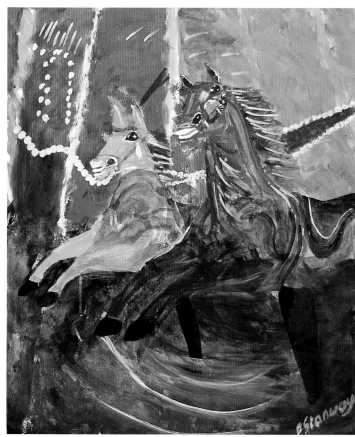

LAYER THE PAINT

Many starter artists think they can paint pictures using a single layer of paint and are then disappointed with the result. You can improve the look and 'feel' of your paintings by applying some or all of these layers to your support:

1 **Size**: a proprietary product, PVA glue, or wallpaper paste

2 **Primer** or 'ground' acrylic 'gesso' primer (white or coloured emulsion or acrylic paint for acrylic painters; acrylic 'gesso' primer, oil-based primer or oil paint for oil painters)

3 **Colour-wash** of dilute paint – dilute with water for acrylic paint, and turps or other solvent for oil paint – but do this only over white primer. You might choose ultramarine, cobalt blue, raw umber, burnt umber, raw sienna, yellow ochre, soft grey, soft green, or a mixture of cadmium yellow and alizarin crimson, or of cobalt blue and alizarin crimson. When you add the final coats (see points 4 and 5), let some of this colour-wash show through

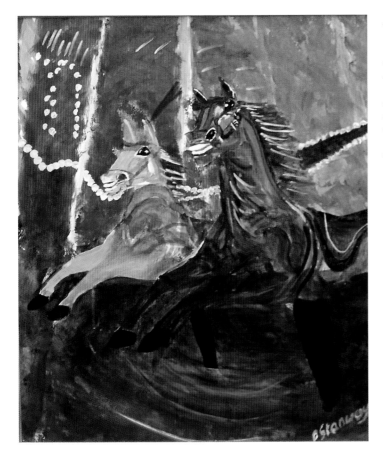

Merry-go-round – stages 1, 2 and 3, 2008

Two-year-old Margot cried unconsolably as she went around and around on this carousel with her mother. But afterwards, as she walked away, she stopped, turned back and begged for another go. I started with a sized and primed board then used blocks of red, green and blue, the low viewpoint of a toddler, and swirls and dots of light to give a sense of her excitement and fear

acrylic on board, 61x51cm (24x20in) x 3

4 **'Draw' with a brush using dilute paint** (you might choose ultramarine, which is particularly good for landscapes; raw umber; or a mixture of cobalt blue and alizarin crimson). Unlike pencil lines, painted ones won't disappear as you add paint

5 **Underpaint** the main areas in dilute paint (perhaps of a colour listed in (3) above

6 **Block in the main areas** with final colour paint.

At every stage of this layering process you can control the effects, with endless creative possibilities. Painting a black dog simply by using black paint on a plain background will never achieve this. Layering can take a picture from being okay to being magical – and you are in charge of the magic.

OTHER TECHNIQUES I PARTICULARLY LIKE

- **Splatter** a painting to produce little droplets of colour. Either pull your finger through a paint-laden toothbrush or, for bigger droplets, tap a paint-laden paint brush against another brush. Gold splattering produces a particularly lovely effect

- For the *impasto* effect of thickly applied paint, put paint on with a painting knife. Unlike a palette knife, which is used for mixing paint on a palette, or cleaning a palette, a painting knife has a swan's neck to keep the handle and your fingers away from the paint on the support. Alternatively, squeeze it direct from the tube then modify it with a brush or painting knife if necessary

- For a **collage** (a picture including various stuck-on materials), try pieces of patterned or metallic paper, ribbon or gift tape or silk, velvet, net, embroidered or patterned fabric, or small objects such as shells. One marine still life I did combined paintings of shells with actual stuck-on shells, plus stuck-on cut-outs of pictures of shells from a cardboard box that had contained paper tissues. The effect is surreal and exciting in a way that a simple painting could never be

- When painting a lot of anything (such as **flowers or pebbles**), paint only a few precisely, choosing the more important closer ones. The mind's eye of the viewer will fill in the rest

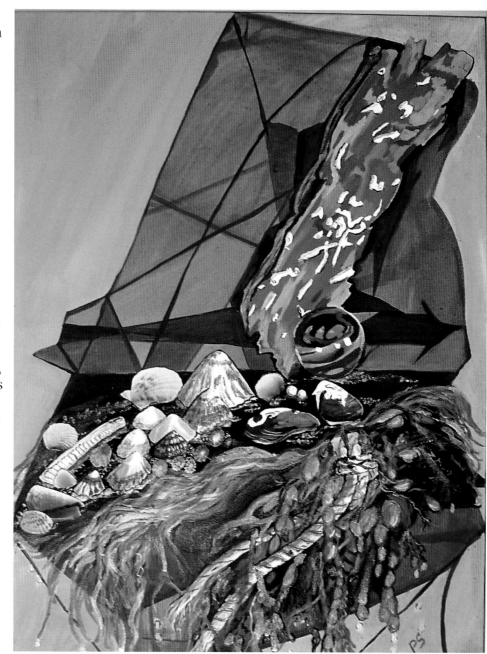

- Place the **main focus** of a painting at about one third of the total height from the top or bottom, and one third in from one of the sides

- Give each object **a background and a base** (unless you want objects to look as if they are floating)

- Try using a **fine felt-tip pen** to strengthen outlines and pick out detail

- **Brush in the direction an object grows or goes** to give it a natural-feeling life and movement

- Try painting in **dashes, waves, swirls, or a plaited or woven pattern,** like the impressionist painter van Gogh

- **Use several fine brushes** together, either held between two fingers or taped together, to produce fine parallel lines (useful when painting things like grass). Or apply the paint with the edge of a piece of card, or even an old credit card.

CLEANING UP

Buy and prepare everything you need to make cleaning up as easy as possible – or at least as little of a nuisance as necessary. Either smooth some barrier cream – for example, silicone-containing hand-cream (such as Atrixo) – into your hands before painting, as this makes it much easier to clean your hands afterwards, or wear thin disposable latex rubber or plastic gloves. A plentiful supply of kitchen paper is a vital stand-by for many jobs, including blotting water from a brush, wiping mistakes from a picture, cleaning hands, and so on.

For cleaning up acrylic or other water-paint you'll need a scouring pad and a washing-up brush. Use left-over paint to prime unused supports and to take the opportunity to play with this paint by scribbling and generally letting your brush do its own thing. Your inner artist will love this and you could produce some attractive or interesting images. The image on one support I primed with left-over paint looked to me remarkably like the head of a jazz singer. It took my fancy so much that I hung the canvas on the wall so I could go on enjoying it.

Some artists who use acrylic paint clean up properly only occasionally. Instead, they spray water over any paint remaining after painting, then cover their palette with cling-film (Saran wrap in the US). Or you can use a 'Stay-Wet' palette (produced by Reeves), or a home-made version. For the latter, put into an aluminium foil food tray a thin layer of sponge. Cover this with two sheets of kitchen paper soaked with water. Then over the top lay a semi-permeable membrane sheet (such as one of those in a Reeves Stay-Wet palette refill pack). Paint mixed on such a palette stays moist for days if covered with cling-film or aluminium foil at the end of each painting session.

At this point it's worth mentioning that brushes and other implements used for acrylic paint need to be kept wet at all times to prevent the paint hardening on them and thereby ruining them. Wash brushes in warm soapy water after a painting session.

Those are Pearls – 'Full Fathom Five', 2005

Below the razor shell and between the two limpets you can see a real, glued-on cowrie. This was my late father's favourite shell. The two pearls between the limpets remind me of a line in one of his favourite poems, 'Full Fathom Five Thy Father Lies', by William Shakespeare

acrylic and collage on canvas, 61x46cm (24x18in)

For cleaning up oil paint you'll need a suitable container for brushes and painting and palette knives, plus plenty of solvent (such as turpentine substitute – also known as 'turps' or white spirit). Some oil artists rarely clean their equipment. Instead, when they have finished each layer of a painting they leave their brushes, etc, immersed in solvent, and either cover the unused paint on their palette with cling-film and put it in the freezer, or brush out the unused paint on a spare canvas or other support, then either scrape any remaining paint off with a blade or palette knife and wipe this away with newspaper, or wipe it off with a rag or with kitchen paper.

In the next chapter we'll look at what to paint ... and how to involve your inner artist in the choice.

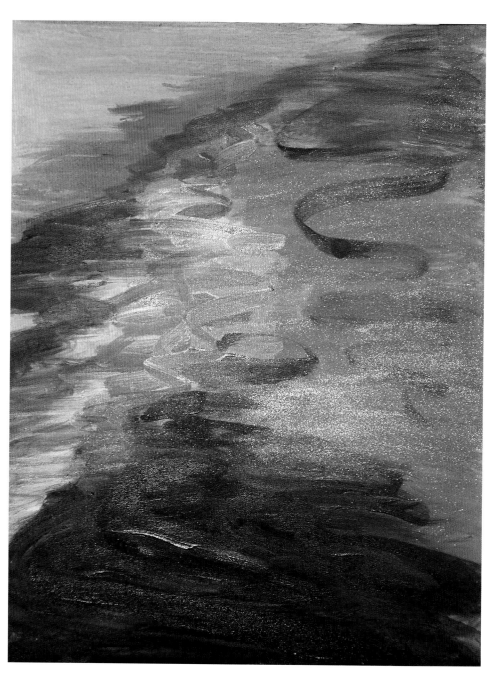

__Jazz Singer__, 2005

This painting resulted from using up leftover paint from an entirely different piece of work. I added to it after each of several sessions of work on the other painting. Since then, each time I look at it, I see a dark-haired jazz singer with her face profiled against a blue background

acrylic on canvas, 61x45cm (24x17¾in)

Chapter Three – What to Paint

Imagine you are all set to start painting and you're facing a blank piece of paper, board or canvas. How will you know what to paint? Some people never find this choice a problem but for others it's a real dilemma. The good news is that your inner artist can help you decide.

LOOK WITH AN ARTIST'S EYE

Artists vary enormously in how they choose what to paint. Some see potential for a picture in almost everything around them. The poet John Betjeman described this quality in his friend, the artist John Piper (1903-1992), as 'the seeing eye'. The ability to see potential paintings everywhere is one of the great delights of being an artist. Not only does it increase our awareness of beauty but it can also bring a touch of excitement, magic or ease to the most mundane of environments or the most taxing of experiences.

It makes sense to cultivate this power of observation, because the more we practice our art, the more likely we are to 'see' with an artist's eye. We begin now to tune into attractive colours, tones, shapes and groupings in the most unlikely of places. Every journey, such as to

> 'No great artist ever sees things as they really are. If he did, he would cease to be an artist.'
> (Oscar Wilde; 1854-1900; playwright, poet, author)

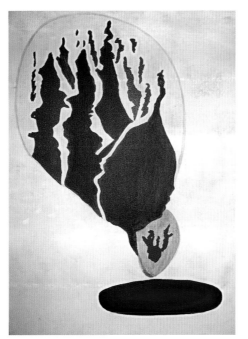

Coffee Grounds 1, 2009
Coffee Grounds 2, 2009

Coffee grounds can provide intriguing images, as in this photo, which to me suggests tepees by a lake, and in this painting, which to me suggests a snowy, tree-clad mountainside with a stream running down towards a deep pool

far left: *Coffee Grounds 1, photo*
left: *Coffee Grounds 2, acrylic on canvas 61x46cm (24x18in)*

Tiramisu Couple, 2009

The hint of an image of two entwined lovers in this dessert bowl could become the inspiration for the subject of a semi-abstract painting

photo

'Children can spend hours looking at wallpaper, seeing things that adults never see.' (Tracey Emin; born 1963; artist)

work, to the shops or to pick up children from school, gives our seeing eye the chance to recognize potential art images and to sense the emotional resonance or opportunity they evoke.

Most important, though, is that each artist sees things in their own way and paints a unique view based on what they see.

Saying someone has an artist's eye is another way of saying that their inner artist is free. When we frequently find ourselves noting images to capture later in paint, we know that our creative energy is up and running.

USE YOUR SIXTH SENSE

Over time, aim to cultivate the skill of 'seeing' or sensing important things that can't actually be seen or said, so you can eventually come to paint the essence of a person, situation or idea. This sort of art can be extremely powerful to both the artist and the viewer. It delves beneath surface appearances to tell an underlying truth. A good portrait painter, for example, captures the essence of a person's real nature by coming to know the individual and seeing beyond their social mask.

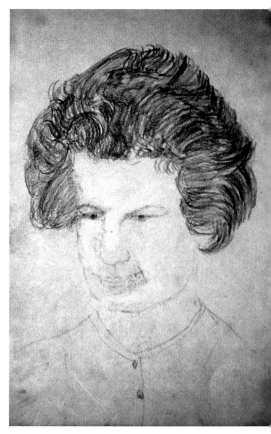

Bobby, 1960

The gentleness, steadiness and thoughtfulness of this teenager come across in this sketch

pencil on paper, 25.5x17.5cm (10x7in)

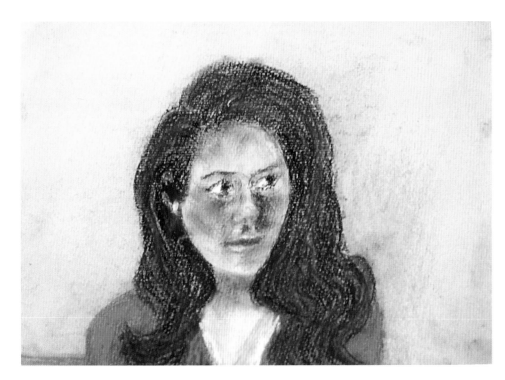

Amy, 2006

This 'instant' portrait captures some of the hallmarks of this young woman … her beauty, individuality and watchful awareness

pastel on paper
21x29.5cm (8¼x11½in)

SHOW WHAT'S REALLY HAPPENING

Some artists focus on making social or political comments through their painting. Art can convey important messages in ways that words or speech cannot. And it can do so very economically. A poignant, astutely observed picture can, at a glance, say more than a leading article written by an intellectual expert in a heavyweight newspaper.

THINK OUTSIDE THE BOX

Rather than being stymied by the actuality of your subject, you may sometimes want to let your mind roam to associate ideas and images that you can then incorporate into your painting. Of course this won't suit a purely representational style of painting, but it can greatly enrich the work of an artist who is prepared to think outside the box. Try letting go of your 'inner critic' that says you shouldn't paint anything unusual or odd. If this inner critic seems to bully you, be assertive or even defiant, and go ahead.

BE INSPIRED

If knowing what to paint remains a challenge, you could be more readily inspired if you:

- Recall your dreams as soon as you wake in the morning. Then note them down or sketch some of their scenes (see page 81)

- Keep a sketchbook or camera handy for recording interesting images you come across in everyday life

- Keep a notebook to record stream-of-consciousness thoughts for perhaps ten minutes a day

- Paint a familiar subject that already attracts you – such as a

pet, or trees or flowers in your local park, or garden

- Visit places of beauty and inspiration, such as art galleries (see page 61), woods, rivers, gardens, the seaside or the countryside. Note that I say 'inspiration' here. This doesn't necessarily mean choosing conventionally beautiful or striking images, for you might be struck by the image of an old person sitting alone, or a pile of rubble on a building site, or some other at first unlikely image

- Meditate each day by relaxing for up to half an hour and letting thoughts and images drift through your mind without dwelling on any of them

- Watch DVDs of an artist working and copy their style

- Follow the exercises in a 'how-to-paint' book

- Attend art classes, where the teacher gives a subject

- Join or assemble a painting group and take it in turns to choose a subject

- Copy someone else's painting that you love

- Express the strength of your feelings about an event by releasing them through painting

- Take several digital photos of an attractive subject and use them for inspiration – bearing in mind that you may decide to use only a small fraction of one photo, or to amalgamate parts of several, as your painting guide.

All these activities can nourish your inner artist, encourage you to see with an artist's eye and fan the flames of your creativity.

WHAT MAKES SUBJECTS ATTRACTIVE

One of the most likely things to draw an artist to a scene is its **beauty**. If we paint a picture of something we find beautiful it will remind us of its beauty each time we look at it. There's surprising unanimity over what's considered beautiful, which is one reason why certain paintings are enduringly popular.

Any subject of **personal or public interest** can be attractive to an artist, be it a place, object or person.

Something of personal interest will probably hook our inner artist most.

The **emotional resonance** evoked by an image or experience is another potential hook for an artist on the lookout for a subject. If an image or experience touches us enough to lead us to want to paint a picture of it, the chances are it will touch us every time we look at the finished painting. Something about the way we record its emotional significance may touch others too.

Our 'choosing muscles' can be influenced either overtly or at an unconscious level by any symbolism embedded in a potential subject. Such symbolism may be of personal importance or widely or even universally accepted. Symbols include such things as particular colours, tones, shapes, objects, clothes and even facial expressions. Over the centuries artists have made use of symbols as a shorthand way of recording and communicating meaning. Art historians are adept at interpreting and disputing messages apparently encoded in paintings. We can introduce symbolism into a painting either because it's already present in our subject, or because we choose, whether consciously or

unconsciously, to add it as an extra device. Either way, it will be apparent to us every time we look at our picture, and onlookers will have the opportunity to resonate with it or to puzzle over what we mean by it.

What's so fascinating about **symbolism** is that other people can often see symbols in our work that we never consciously intended to be there. It is this openness to interpretation - not to say naked-ness - that makes some of us wary of exposing ourselves as artists. This is just one of the reasons that freeing your inner artist can seem so courageous - as indeed it is.

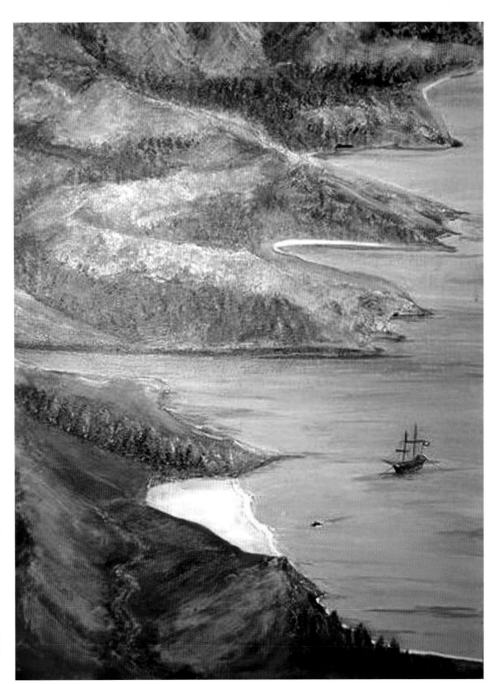

Pirate Cove, 2006

The natural line of the plywood grain morphed into a coast of coves. Unusual colours suggested heat, mystery, even danger. Then a pirate ship appeared and a single oarsman makes for land...

acrylic on board
80x60cm (31½x23½in)

Another thing that can make a subject attractive to an artist is an air of **mystery**. This could be an indecipherable facial expression, as in the 'Mona Lisa', by the Renaissance artist Leonardo da Vinci (1452-1519); an inexplicable event, as in 'Time Transported', in which a train emerges from a fireplace into a sitting room, by the surrealist artist René Magritte (1898-1967); or a sudden disappearance, as in 'A Bigger Splash' by the contemporary artist David Hockney (born 1937).

Finally, there's the recognition that a subject has **religious or other spiritual significance** to us. Millions of people around the world – such as the Eastern Orthodox Christians who revere their religious icons – find worth of this sort in certain paintings. In the UK, the artist Sarah Ollerenshaw (born 1972, www.sarahollerenshaw.co.uk), herself a Christian, has produced a series of paintings of 'holy people' that can touch viewers with a sense of the existence of a sublime power for compassion and good. If an image or an idea impacts on us this way, it's well worth consideration as a subject for an artwork.

To sum up, we may decide we want to record, express or communicate something we find beautiful, something of personal or public interest, something that has resonated emotionally in us, some sort of symbolism or mystery, or something of spiritual significance.

TAKE PHOTOS TO AID IMAGINATION AND MEMORY

A digital camera is a wonderful tool for artists because it means we don't need a sketchpad and pencil at the ready to capture interesting images.

With a camera we simply snap anything we find appealing and upload it later on to a photo-management programme on our computer. There we can delete unwanted images and store others. We can also enhance images by:

- Cropping
- Straightening
- Magnifying
- Lightening or darkening
- Adjusting the contrast
- Saturating the colours
- Changing the colour, perhaps to black and white, or sepia
- Flipping an image horizontally or vertically

- Retouching – meaning altering an image by drawing or deleting lines or changing the colour of certain areas.

Photoshop is one excellent photo-management programme. Older versions can be downloaded free, or you can buy the most up-to-date over the internet or from a computer store. I like Picasa – a useful though less comprehensive programme that's available to download free.

Having photos ready to view in an instant on a computer screen makes it remarkably easy to remind ourselves of images we find attractive. By looking at certain views of a subject we may find that some are more likely than others to make a good painting. It's also possible to select parts of several photos and amalgamate them into one painting.

What's especially useful is to print out a photo to use as a reference while actually painting. Some people give themselves a helping hand by using a projector to beam a magnified image of a photo or other picture on to their paper, board or other support. They then

draw or paint around the main lines of the projected image, and fill in the rest of the image freehand later. Of course this is a cheat of sorts. But several great artists have used some sort of projection or other copying mechanism as an aid, and if it helps, why not? There's no point, though, in recreating the exact image captured by a photo. This not only requires considerable technical expertise but is also very tedious. A painted copy of a photo would be dry and dull as opposed to the magical effect of a picture fuelled by your creativity. The point of projecting an image is that outlining it can get us started. Our intuition and other aspects of our creative energy can then enable us to continue the image in a painterly way (meaning with pleasure and sensuality in the manipulation of the paint) and to get the enjoyment of working with our inner artist.

Digital photography can be a huge aid to creativity and to my mind is one of the best things that has happened to artists for a long time. I recommend using a small camera that's light and easy to carry and use. My little Samsung has served me brilliantly for more than five years and given me enormous pleasure as a starting point for recording paintings and images that I might one day paint.

My best photo opportunities always seem to occur when I've left my camera at home, so I try to remember to keep it with me wherever I go and to pack some spare batteries too.

KEEP TEAR SHEETS

Whenever I see a printed image that I love, I either keep it, cut it out (if in a newspaper or magazine) or scan it. This way it's easy to build an image bank that will one day provide me with an idea for a painting. If you actually copy a painting it's customary and also good manners to add 'after xxxx (the artist's name)' to the title.

Please note, though, that painting an accurate copy of someone else's published photograph is a breach of their copyright.

REPEAT AND LEARN FROM PREVIOUS WORK

Some artists repeatedly paint the same scene or subject. For example, Claude Monet (1840-1926) painted

*When asked what stimulates his work: 'Absolutely b****y everything that happens to me. Life round the corner. The newsagent not saying good morning. It's the tiniest things.' (Frank Auerbach; born 1931; artist)*

haystacks, and Rouen Cathedral, many times; Paul Cézanne (1839-1906) repeatedly painted Mont Sainte-Victoire; and Vincent van Gogh was drawn again and again to painting wheatfields. In each set of paintings, though, there are subtle differences – perhaps a different light or angle, or a new way of applying the paint – which make each picture unique in its own right.

We too can repeat pictures if we want to make alterations or improvements, or feel particularly drawn to a subject and want to paint it in other ways or in other lights. One interesting thing to try is to display a digital photo of one of your paintings on your computer screen and then use a photo-management programme to adjust its colours, tone and scope. This way you can easily practice what might take hours to do with painting. Once you have a satisfactory outcome, take a print-out to your easel as a guide for your painting.

LEARN FROM OTHER ARTISTS

Throughout history, many great artists have copied from one another, perhaps because they especially liked a painting and wanted to learn from its style. However, it's one thing to copy someone else's painting if it's then labelled as a copy of their work, and quite another to pass it off as yours and yours alone. One modern-day copier, John Myatt (born 1945), paints with enormous expertise in the style of various acclaimed artists. His intellect and his inner artist enjoy a successful collaboration and his TV programmes make extremely good viewing! But at one time he was imprisoned for art forgery.

Art students are often advised to polish their craft by copying from the works of great artists. Learning this way can certainly be useful, partly because we focus on different ways of applying paint and putting colours together. However, what we are after is to develop our own unique style, so it's worth bearing in mind these cautionary words from Michelangelo:

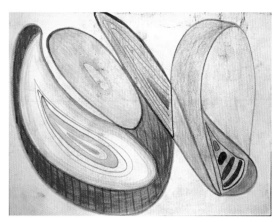

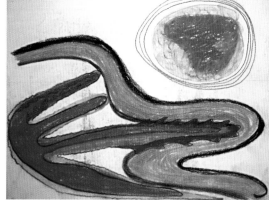

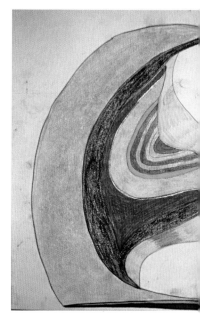

> *'He who goes behind others can never go in front of them, and he who is not able to work well for himself cannot make good use of the works of others.'*
> (Michelangelo di Lodovico Buonarroti Simoni; 1475-1564; Renaissance painter, sculptor, architect, poet, engineer)

USE YOUR INTUITION

Another way of finding the subject for a painting is to let go of your preconceptions, follow your intuition and allow your inner artist to direct your brushes. This completely spontaneous and intuitive painting means bypassing your conscious mind and allowing your brushes to make marks unguided by your thinking brain. Try it and see. It involves giving up all conscious responsibility for choosing brushes, selecting colours and creating marks. Once you get going, your creative energy will guide you and let you paint direct from deep inside yourself – from knowledge stored in the right your brain and even in other parts of your body. The colours, strokes, composition and symbols will be all yours but will nonetheless surprise you with their freshness and power. You'll probably produce a painting that looks completely different from anything you've ever done before. It may be an abstract or a representational painting, or a combination of the two.

Spontaneous painting of this sort is very much akin to the sort of journal writing that lets words flow through your pen without any conscious editing or directing. The aim is to release creative energy and ability that would otherwise have been trapped inside.

PLAY WITH PAINT WHEN YOU DON'T HAVE A SUBJECT

If you have no clue what to paint, try simply playing with paint. This is inherently conducive to creativity, because our inner artist loves playfulness. Play is vital to its wellbeing and productivity.

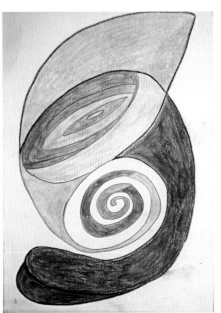

left to right: *Abstracts x 6, 2005*

When unfettered by conscious guidance, your hand may lead you to create images that you might never have imagined

pencil and crayon on paper, 21x30cm (8¼x11¾in) or, for third and fourth pictures, 30x21cm (11¾x8¼in)

Watered Silk, 2005

The jagged marks made with the side of a crayon tip soon took on something of the appearance of watered silk – though this wasn't at first intended

crayon on paper
29.5x21cm (11¾x8¼in)

I have a play session at the end of each painting session when I use up leftover paint before washing my palette. I apply the paint dregs to a primed board or canvas with a sponge, large brush or my fingers. This is when it's easiest of all to be free with paint, because there's no goal, just the opportunity to make marks and shapes and mix colours *ad lib*. Sometimes, just sometimes, the ghost of a beautiful or interesting image starts to appear. Once, my just-daubed marks on the canvas revealed a clear image of two cats sleeping on the edge of the wide blue yonder. They weren't meant to be but they continue to give me pleasure and you can see them on this book's front cover. There's no way I would have captured the jazz singer in this way if I'd consciously tried. Playing with paint gives us the confidence to paint in a wonderfully loose and free fashion, aided, of course, by the inner artist at our elbow.

Next time you're stuck for a subject, get out some paints (old, dirty or cheap ones will do just fine) and paper. Now **let yourself go with the paint, using fingers, twigs, brushes, sponges, droppers, cookie cutters or cut-out shapes of card** … anything goes. Be inventive. Swirl the colours into each other and try to let your hands be guided by your hara – the energy centre ('chakra') defined by Eastern mystics in the centre of your belly. If ripples of laughter well up, so well and good. Your inner artist may not always need a subject – sometimes it just needs to have a good time.

Another idea is to **do some marbling**. This will give you a break from having to find a subject. You'll almost certainly enjoy it. You might produce some pieces of marbled paper that you like enough to incorporate into a collage, to frame as they are, to develop into a

Emily Winifred, 2005
Jennifer Jill, 2005

Discerning the qualities that define the characters of the faces of these two women helped me understand more clearly what makes them tick

right: *Emily Winifred, pencil on paper,*
25.5x18cm (10x7in)
far right: *Jennifer Jill, pencil and crayon on paper, 25.5x18cm (10x7in)*

painting, or to use as a gift-wrap. You'll find detailed instructions for marbling on the internet and simple ones in the box on page 61.

Yet another way of using play to find a subject for a painting is to cut up paintings you don't want to keep, and then to stick the pieces on to paper to make a collage. Alternatively, paint some sheets of paper especially for cutting up. If you do this, create special effects by varying the colour and thickness of the paint, by using highly figured brush-strokes, and by making unusual shapes. You can let your imagination run riot. You could also use materials such as tissue paper, gift-wrap, ribbon, raffia, theatre or other tickets and even seashells. Play with your materials by arranging them in different ways and groupings before you stick them down with gum. As you play, an attractive image may emerge of its own volition. The collage you create could be an end in itself or you could use the image as the starting point for a new painting.

TRY YOUR HAND AT CARICATURES

If you haven't a clue what to paint, you might enjoy attempting a caricature. Try starting with a familiar person's face. Aim to exaggerate the features and 'essence' that define the person, so the image is immediately identifiable even though you haven't produced a good likeness as such. There's nothing like practising caricatures to hone your skills of observation and evaluation of a face.

This skill will rub off on to other subjects as you get better and better at seeing the essence of the things you paint.

LOSING AND FINDING YOUR SUBJECT

What should we do if we realize in the middle of painting a picture that we don't know what we're trying to achieve? This has often happened to me when painting abstracts. What I'm doing seems like a good idea at the start but the magic then evaporates. Sometimes it helps to retrace the history of the brush-strokes I've done since last feeling excited or pleased with the picture's progress. This can help me paint my way back to where I was by covering up the intervening work.

Alternatively, how about putting the unfinished picture to one side and leaving it there for days, weeks, even months, until the muse comes again. Yet another idea is to paint a fresh priming coat over the whole thing and start again another time!

Emily Winifred

Jennifer Jill

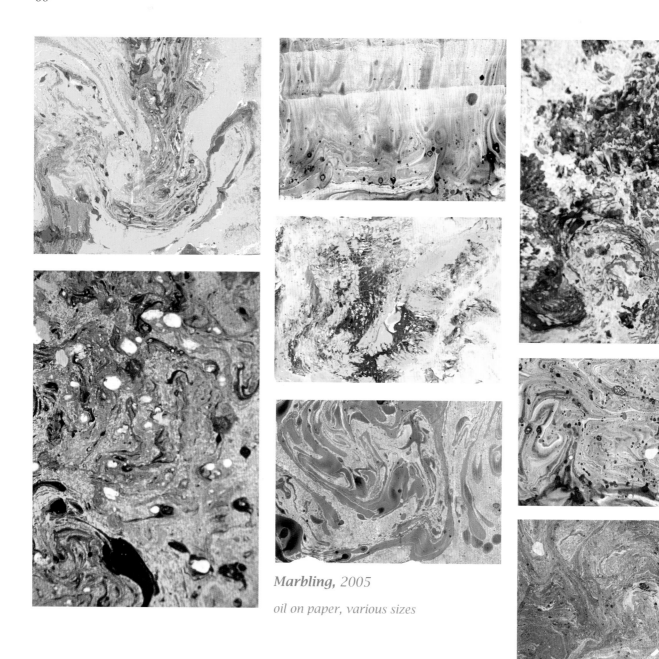

Marbling, 2005

oil on paper, various sizes

MARBLING

Half-fill with water a large shallow container (such as a disposable tin-foil roasting tin). Stir in enough wallpaper paste to make a runny jelly; this makes it easier to produce patterns and also prevents the paint or ink sinking.

Add a few drops of different-coloured acrylic paints or water- or solvent-based inks from a teaspoon or dropper on to the water's surface.

Swirl the paint or ink into patterns with a fork, comb, brush or stick.

Lay a piece of paper flat on the surface of the water for up to 20 seconds, to pick up a layer of colour.

Drain off the surplus water. Let the paper dry flat.

Repeat with additional sheets of paper to make prints that are increasingly pale.

Alternatively, use oil paint, or solvent-based ink, and no wallpaper paste.

Don't be in too much of a rush to repaint, put to one side, or reprime, though, because you might simply need to continue painting to 'find' your subject again. I once saw a series of selected still images from a film of a portrait being painted. It was all too apparent that the likeness of the subject came and went several times, as more layers, colours and brushstrokes were applied and removed. So before you reverse, put by or reprime a painting, trust your inner artist to be your 'seeing eye' that will help you build up your painting.

Not all the stages of a painting produced by our inner artist are necessarily likeable or acceptable, but if we give our creative energy free rein it will continue to work towards a good result.

UNRAVEL WHY OTHER PEOPLE'S PICTURES ATTRACT AND INSPIRE US

Knowing what it is about someone else's painting that attracts and inspires us can help us learn what more to add to our own paintings.

ART GALLERIES

To aid the process of freeing your inner artist, I can't encourage you too much to visit exhibitions in art galleries and artists' open studios

An artistic picture isn't just a good likeness but has extra 'oomph' or fascination which makes it particularly pleasing, interesting or provoking and evokes emotions, memories and thoughts that touch the viewer and make many people – including ourselves – want to go on looking at it. Some painterly artworks have such presence that they literally stop us in their tracks.

and to look at pictures in friends' homes, restaurants, magazines and wherever else you see them. Try to work out what attracts and inspires you and why this may be. Don't for an instant be put off by any notion of a gallery being too elitist, fusty or musty for comfort. And never be intimidated by how little you know about the history of art!

Art galleries are there to delight or intrigue us as individuals and to store artworks that have delighted or intrigued past generations. When viewing paintings, my advice is to spend most time with the ones you like best and to walk straight past

WHY A PAINTING ATTRACTS OR INSPIRES YOU

Look at a painting that speaks to you and consider the artist's:

* Subject matter

* Colours: including their number, the mix of primary and complementary colours, and their tonal range (very bright to very dark, or a more limited range)

* Professional techniques: including the positioning of the main areas of interest, the viewpoint, the lighting, the degree of complexity and the types of brushstroke

Notice any:
* Symbolism
* Surprises
* Quirkiness
* Magic
* 'Crystallisation' of emotion

Assess the frame's:
* Size
* Material
* Bulk
* Pattern
* Colour
* Sheen
* Mount (Single or double? Colour?)

* Finally: decide whether you think the frame suits the painting. When visiting an exhibition of the semi-abstract artist Howard Hodgkin (born 1932) at Tate Modern in London some years ago, my sister and I were delighted that several frames had shapes and colours echoing those in their paintings. I found myself saying that Hodgkin was lucky to find frames that matched the paintings. Our subsequent ripples of laughter broke the silence of the large, white, hushed space!

those that don't impact on you at all. We don't have to follow the herd and study everything, and there are certainly no prizes for noting each painting. Life is too short to be bothered with also-rans. Instead, let yourself admire and learn from whatever is pertinent to you. If you aren't interested in art history, don't waste time reading the curator's captions. Just enjoy and study the colours, composition, style, emotion, energy or whatever else captures your attention, and decide how these aspects of a particular painting could influence you and your work.

Visiting a recent exhibition of the work of Sir Anthony van Dyck (1599 -1641) – the Flemish baroque artist who became England's leading court painter – I was struck by his careful portrayal of his subjects' enchantingly patterned lace collars and cuffs and exquisitely textured clothing in shades of gold, carnelian and lapis lazuli. His expertise inspired me to want to paint gloriously coloured clothing in sumptuously shiny silks and soft gleaming velvets. His arguably somewhat amateur (at least in his earlier works) painting of hands

matters not a jot. It's his fabrics that sing for me.

Several paintings in the current (at the time of writing) exhibition of paintings at the same gallery by JMW Turner (1775-1851) delighted me in a different way. Joseph Mallard William Turner was a romantic landscape artist who is said not only to be the greatest English painter but also to have laid the foundations for impressionism. He often used wonderful sweeping and swooping brushstrokes to convey a feeling of excitement and motion. Indeed, some of his seascapes create such an impression that the waves are moving in a potentially dangerous way that they almost make me feel sea-sick.

But best of all for me and my inner artist are two paintings that were tucked away in a small room high up in the gallery. Not knowing they were there, I should have realized that they were something amazing when I saw a guard sitting close by. Each painting was done in the dark and light style known as chiarascuro, and was roughly two feet (600mm) square. Both singly and together they grabbed me by my throat and tummy and had me standing in a strange combination of captivity and rapture for many minutes. When I eventually turned and exclaimed my delight to the guard, he gave me their potted history. The paintings were 'Shade and Darkness – The Evening of the Deluge' and 'Light and Colour – The Morning After the Deluge'. They had been stolen in 1994 while on exhibition in Germany and recovered between 2000 and 2002. They enchanted me and I determined to have a go at copying them.

What was the attraction? I think it was the apparent movement of the oily darkness, plus the symbolism of the faint outlines of the ark and a few pairs of animals, plus the intrinsic hopefulness of the light.

On my return home I was surprised to find that my husband had, quite coincidentally, salvaged a large packing crate and asked his carpenter to cut it up and use it as the backing struts for two sheets of marine plywood he'd bought for me to paint on. The size of each sheet was about two feet (600mm) square! The perfect size and shape for my intended project.

You might like to:

- Keep a note of those artists whose work you particularly enjoy, and collect copies of your favourite works by each one; many are available on the internet for free. Stick them up around you in your painting space so they can inspire you at an ongoing and unconscious level

- Note what it is about each painting that you like so much

- Consider whether you could include some of the techniques or colours you admire into your own work.

In the next chapter we'll look at how our inner artist can help when we're actually painting.

Chapter Four – Painting Pictures

Freeing our inner artist provides creative energy that gives voice to our passions. It also encourages us to paint in a more artistic way, develop our own unique style and derive more pleasure both from the process of painting and from the product itself. You can get ample information about painting techniques from books, DVDs, the internet and art classes. What I particularly want to explore here is how you can contact your creativity before and while you paint.

USE YOUR WHOLE SELF

Some artists spend a lifetime painting without ever fully realizing their creative potential. Their paintings may be accurate representations, clever abstracts or well-executed combinations of the two.

'Every artist dips his brush in his own soul, and paints his own nature into his pictures.'
(Henry Ward Beecher; 1813-1887; clergyman and abolitionist)

'Life beats down and crushes the soul and art reminds you that you have one.'
(Stella Adler; 1901-1992; actor and teacher)

But they are unlikely to touch the viewer's heart, gut or soul unless the subject happens to have personal significance to them. This is because such paintings come only from the artist's left (intellectual) side of their brain rather than also from its right (intuitive) side. In contrast, artists who paint from both sides of their brain, and from their heart, gut and soul, are more likely to produce paintings with widespread appeal or even that intangible 'wow' factor. Their hands have different masters, so their creative output communicates at a deeper level, revealing something of their emotional and spiritual selves as well as their intellectual and technical side. Although all this takes place at an unconscious level, it is perceived – usually also at an unconscious level – by the viewer. As a result they readily identify with the work and find it has real and sometimes surprising meaning for them.

So when we paint, we should aim to use the whole of ourselves. This could mean learning to let go of a certain degree of self control and learning to listen to our inner emotions. Making changes to how much of ourselves we give when painting can be challenging at first, but once we start using all our assets, we never look back. The rewards of using our whole self to boost our creativity can be extraordinarily powerful. The benefits often extend beyond our studio sessions and our paintings to enrich our whole life.

'To find that core that really pleases that deepest part of yourself and is nurturing to it – that is a talent. I think the best artists are the ones that can access it.'
(Grayson Perry; born 1960; artist)

Moonlit Sea, 2008

Starting this picture triggered memories of Daphne du Maurier's 'Frenchman's Creek'. These then steered the painting. It's generally better to take photos before adding varnish but here the varnish lends glitter to the moonshine

acrylic on board, 42x30cm (16½x11¾in); left - unvarnished; right - varnished

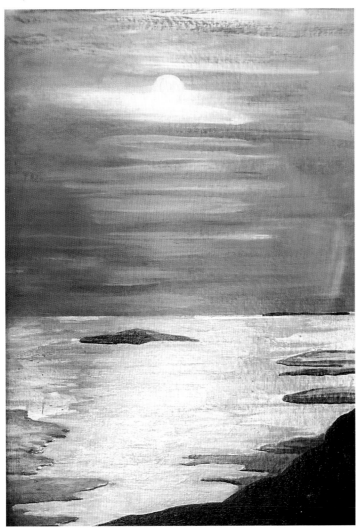 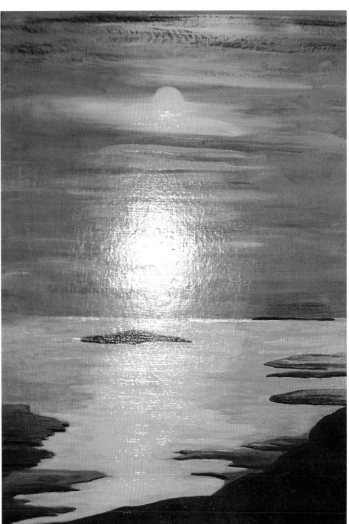

RECOGNIZE FEELINGS

As artists we sometimes find it hard to start painting, or find painting itself a struggle. The longer we put off picking up a brush or continuing a painting, the more difficult it becomes. Arguably, though, the more resistant we are, the more important it is to enlist our inner artist. This is because resistance is often a sign that one or more hidden emotions is blocking our creativity. But if we are able to free our inner artist, our creative energy can flow and carry with it some of the underlying feelings that have been holding us back.

Assuming we've addressed the practicalities (see Chapter One) and have time to paint, a place in which to paint, and the necessary equipment, listening empathically to ourselves can be a good way of overcoming any reluctance or feeling of being stuck. Empathic listening is a very particular sort of listening. It doesn't mean feeling sympathy, concern or sorrow for ourselves. Instead, it's about recognizing and naming any difficult, overwhelming or otherwise challenging emotions that our unconscious has hidden away. It's important to realize this is happening because repressing emotions saps valuable energy that could otherwise be directed into creative output. If we listen empathically to ourselves – or if someone else listens to us in this way – repressed emotions can well up and escape in a flood of creative energy.

Artist's block is one of many types of emotional defence. Other such defences include anxiety, depression and all the addictive behaviours – for example, eating or drinking too much, smoking, working too hard, over-spending, over-exercising, gambling, misusing drugs and being sexually promiscuous. Unconscious defences protect us from emotions that seem at the time to be too painful or dangerous. Developing a defensive behaviour is usually the only way an individual can deal with their pain at the time. However, times, circumstances and experience change, and we may now be able to deal with previously repressed emotions in a way that doesn't sap our energy by building defences. If listening to ourselves makes us realize that deep-down we are sad, anxious, angry or afraid, we need to take time to experience and accept the emotion. This may feel uncomfortable at first but can release the creative energy we need to enable us to paint. A person who recognizes previously repressed emotions and uses them constructively is like a bud unfurling as a flower appears.

> 'Yes of course it hurts when buds are bursting. Why else would the springtime falter.'
> (Karin Boye; 1900-1941; poet and novelist)

Everyone's life has vicissitudes and those of us who overcome a defence often find it recurs with the next challenge. The best way to deal with this is to recognize what's happening as soon as possible, then to be kind and gentle to ourselves by listening empathically and reminding ourselves that the defence is no longer necessary.

Artist's block is one of many possible psychological stages in the creative process but it's well worth

Luke's Cove, 2006

The idea for these quiescent volcanos around a beautiful cove came after a discussion about a lovely man who is dealing with the challenging highs and lows of bipolar disease

watercolour on paper
21x29cm (8¼x11¼)

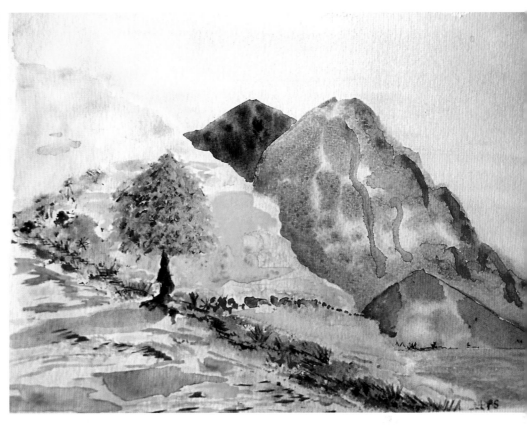

'Seeing this every day fills me with a sensation of struggle for survival, of melancholy ... I am attempting to put this sensation down on canvas by exaggerating certain rigidities of posture, certain dark colours, etc.'
(Paul Gauguin; 1848-1903; post-impressionist artist)

persevering in an effort to discover the causes and the solutions because it so often suggests there is useful emotional work to be done. So next time you find yourself thinking, 'I can't', or 'I won't', don't be disheartened but try to see your lack of self-confidence, your defiance or your apathy as an opportunity that could be the start of a journey of self-discovery or a creative break-through. You might think you have to feel good to enjoy painting. But this isn't true. It can also be rewarding if you're feeling anxious, sad, angry, frustrated, depressed, lonely or whatever. Try it and the results could amaze you. Being 'in the mood' to be creative can mean being in any mood.

PROCESS AND PRODUCT

Some people are much more interested in the process of painting than in achieving a completed picture – the 'product'. The word

'process' comes from the Latin *processus*, meaning 'an advancing'. The process of painting is indeed a moving on, or a journey. The benefit process-centred people receive from painting lies in the doing rather than in the enjoyment produced by the finished product. They may particularly like releasing their feelings on to paper, or using their technical expertise to paint, yet have little or no interest in looking at, showing, hanging or storing the resulting image. For such individuals, working with their inner artist is an intensely personal inner journey. What others think or feel about the outcome is of little or no importance to them.

Every artist feels differently about whether they are primarily process-centred, product-centred, or both – and if both, in what proportions. Personally, I get enormous creative pleasure from the process of painting and great fascination and, sometimes, enjoyment, from looking at a finished painting. I love such things as 'caressing contours' (see page 74) and creating abstract representations of images, but I also feel delighted when I have a picture framed and hang it on the wall or give it away. My advice to anyone keen on freeing their inner artist is certainly to be as much process-centred as product-centred, and perhaps even more so. Allow yourself to be guided by the creative energy of your inner artist, like a candle in the wind, and you'll bring to your painting magic, depth and the unknown.

Whether you are mainly process-centred or mainly product-centred, try to be relaxed about how fast or how slowly you complete a painting. Great painters have always varied enormously in their speed:

- Henri Matisse (1869-1954), the post-impressionist artist widely regarded as one of the 20th century's two greatest artists – the other being Pablo Picasso – needed 30 sessions for one particular still life

- Jean-Honoré Fragonard (1732-1806), a prolific artist who produced around 550 artworks, painted one particular portrait in an hour

- Vincent van Gogh often did a painting in a day. He also completed around 900 paintings and 1,100 drawings in his last ten years.

It's perfectly acceptable to have several paintings on the go at the same time. You might leave one untouched for months then pick it up when you finally realize what it needs, or because it takes your fancy again. The 16th century artist Titian (Tiziano Vecelli, c.1488-1576) often left a foundation layer of paint for months before working on top of it. And all artists who work in oils – unless they paint 'wet on wet' – become used to waiting days or even weeks for a layer of paint to dry.

DISCOVER THE ZEN OF PAINTING

If when we paint we find ourselves in a different state of being, we'll know our inner artist is on board. This energy makes time meaningless and lets us give 100 per cent of our concentration to the work in hand. We may even enter a quasi-meditational state, in which worry, discomfort and other day-to-day concerns take a back seat as we automatically give all of ourselves to what we are doing. Our brush may seem to have a will of its own, making marks without our conscious direction. Some artists, myself included, describe this as feeling as if creative energy is coming from the pit of their stomach – the place that traditional Chinese medicine calls the hara, or seat of internal energy. When I paint with my inner artist, I feel a strong physical sensation right there. And I feel that it's this rather than my head or my hand that is directing my brushes. At the same time, I often feel happy, enthusiastic, warm, excited, hopeful and playful. The act of creating has surprisingly powerful effects.

Angels x 6, 2005

The first of this host of angels appeared as I was idly playing with some left-over scraps of marbled paper; it then took very little time to assemble the rest and make all their wings glisten with iridescent paint

Aqua, Bleu, Jaune, Rose, Rouge, Vert, acrylic, acrylic collage and iridescent paint on paper, each 30x42cm (11¾x16½in)

Ballerinas and Wands, 2006

My delight in a photo of circus ballerinas with wands of shooting stars made my fingers and paintbrush want to dance. The upper of the two paintings was done in a few minutes, the lower one even faster

photo of portfolio page

Besides being beneficial for my artwork, I find that experiencing a meditational state while painting has benefits in other areas of my life. I usually continue to feel on good form for hours, if not days, after a satisfyingly creative session. Buddhists might explain this state as a type of 'zen meditation' – the sort of meditation we can do while carrying out any of the activities of everyday life. Robert M. Pirsig (born 1928) described this in his book, *The Zen of Motorcycle Maintenance*, while Brother Lawrence (1614-1691) wrote about it in his book, *The Practice of the Presence of God*.

Some artists encourage a creative and meditational state by relaxing their muscles and breathing steadily and slowly – perhaps imagining themselves breathing in creative energy ('in-spiration') and breathing out stress or other blocks.

Meditation has provable health benefits, such as a reduction in high blood pressure and stress levels. Meditation experts believe that the practice encourages people to change from being mainly self-centred to being more other-centred, implying that they become less selfish and more altruistic. It's also said that meditation helps a person bypass their 'ego' to become more in touch with their 'true self'. In this way they cast off their 'shell' or 'false self' and come face to face with who they really are.

If you think this all sounds rather boring or fanciful, be warned that your experience may be the opposite. Many creative people report high levels of emotion as they work, perhaps feeling excited, sweating, their pulse racing, and time flying by. This helter-skelter ride can be exhausting but fulfilling. Those of us whose inner artist takes flight like this find it rubs off into everyday life as we feel more energized and 'switched on' in general. Others find that such highly-charged sessions exhaust them so they need to recharge their emotional batteries afterwards. In this sense it's often impossible to make a creative 'omelette' without breaking a few 'emotional eggs'.

'BE STILL AND KNOW THAT I AM GOD' (PSALM 46, VERSE 10)

The creative energy that powers people who paint with their inner artist frequently precludes them from talking, thinking or even hearing the doorbell or phone. This is because using language – in speech or in thought – can be a real barrier to creativity, so when we are riding high on creative energy, we are likely to be both outwardly and

inwardly quiet. The letting-go of our dependence on language opens us up not only to being creative and meditative, but also to being aware of the 'infinite' or the 'unknown'.

Certain philosophers have explained this by saying that when we talk our mind is in a 'cataphatic' state. This hinders creativity. In contrast, being creative encourages a more mystical 'knowing' or 'apophatic' state of mind. This encompasses serenity, relaxation, worship, even awe and is what famous mystics of the past – such as Mother Julian of Norwich – aimed their lives towards. It is an important part of our search for the meaning of life and some individuals describe it as being aware of the presence of God.

To attain this state we don't have to do anything or understand what's happening. We just have to be and let it happen. And painting can be a key!

LET THE BRUSHES DANCE
While you are painting, take time every now and then to assess how you hold our brushes and how you make marks with them:

Do you tend to hold your brush tightly? If so, you might be holding in your creativity. Aim to relax a bit. Let those shoulders drop. It doesn't

Jenny's horses, 2005

Fear and apprehension while using oil paints for the first time since my childhood soon gave way to delight in the way my brushes 'released' images of my sister's horses cantering down the fields

oil on paper, 22.5x30.5cm (8¾x12in)

matter if a brush falls to the floor, as long as any vulnerable surfaces and objects are protected.

Q. Do you hold your brush close to the 'painting end'?
A. Try holding it much further towards its upper end – at least half way along, or even right at the very end. This should help loosen up your painting style if it's been somewhat 'tight' and controlled up until now. You'll need to hold the brush closer to the 'business end' if you're doing a small or detailed painting, though.

Q. Do you paint with enormous care?
A. While sometimes essential, this might hold you back if an impressionist-style painting that you're doing calls for a more free-flowing approach.

When your creative juices are flowing, you may sometimes notice that your brushes seem to 'dance' as they paint, so easily do the strokes happen. The result is often very

> *... my brush goes between my fingers as a bow would on the violin... .'*
> (Vincent van Gogh.)

much more pleasing to the eye than a painting done by brushing very carefully. Whatever style you're after, try to let your hands do the talking.

ENJOY LAUGHTER, SEXUALITY AND EXERCISE

Freeing our inner artist can encourage us to laugh more and to be more interested in exercise and aware of our sexuality. Conversely, laughter, exercise and sexual awareness encourage us to be creative. This reciprocal effect makes sense, because working with our inner artist calls us to release suppressed emotions that may have been holding back laughter and our enjoyment and care of our body. Also having laughter and exercise in our life and being aware of our sexuality implies we have healthy amounts of relaxation, joy and wellbeing – each of which encourages creativity.

What's more, the type of spontaneous painting done with the help of one's inner artist can evoke energy, passion, connection, abandonment and a crescendo of excitement and sensation, followed by contentment and relaxation. Indeed, creative energy sometimes resembles a volcano in that its release feels like an eruption and painting feels like a momentous act!

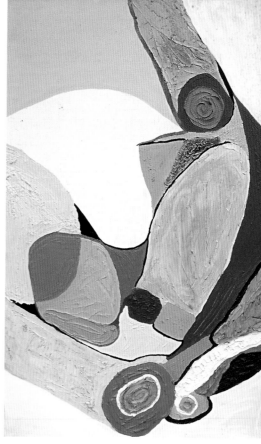

First Acrylic, 1972

One part of this painting automatically led to another and no theme was consciously intended, so I've been amused since by the number of people who have detected clear sexual imagery

acrylic on board, 76x50cm (30x20in)

MAKE THE MOST OF SERENDIPITY AND 'HAPPY ACCIDENTS'

My sister, the artist Jenny Hare (born 1950), taught me to look at a board primed with random strokes of left-over paint and encourage my mind's eye to rove until I could see the beginnings of an image in the daubs. Using her technique I've since painted many pictures that my conscious mind would never otherwise have thought up. Whether or not I begin a picture this way nowadays, I often use the technique of letting my painting guide my imagination, instead of the other way around. Being led this way can encourage serendipitous results and I heartily recommend it.

Another great lesson that has come to me care of two artists – John Simmonds, my art teacher in Ireland, and the late Bob Ross, the North American TV artist – is to look for potential benefits from mistakes. Now, if a drip of paint or ink spills on to something I'm working on, I don't automatically think all is lost, and frantically try to clean up the spill. Instead, I may try tilting the

> *'Happy accidents give a painting a magic quality.'*
> (Bob Ross; 1942-1995; artist.)

support to let the spill flow. It's surprising how often a spill improves a painting! Bob Ross called such mistakes 'happy accidents'.

'FEEL' YOUR PAINTING

Next time you paint, imagine you are using your brush as if you are a carpenter using a woodworking tool. Use lines and shade to 'chisel' and 'plane' two-dimensional shapes so they appear three-dimensional. At the same time, imagine you are using your brush as if you are a lighting designer choosing where to install spotlights, uplighters, floodlights, and so on. Pay special attention to the dark and light parts and the mid tones. What's particularly exciting and empowering about these techniques is that they can help create much more realistic looking representational pictures. We are in effect acting as a creator by making the shapes become what we want them to be. We don't have to be enormously skilled as an artist to do this. All we have to do is observe our subject – whether it's in front of us, in a photo, or in our mind's eye – then slightly exaggerate its contours and its shades of light and dark. With practice, we can all create realistic-looking objects purely from our imagination. In effect, this is rather like becoming a three-dimensional sculptor using a two-dimensional medium.

Life painting of male model, 2007

Meeting the challenge of painting a picture of a naked life model involves 'feeling' the contours of the body with your mind's eye while using paint and perspective to depict three dimensions in two

*gouache on paper
59x42cm (23¼x16½in)*

Another tip to help you make things you paint appear more realistic is to imagine you are touching or stroking them. Focus your mind on the shape, size, texture, protrusions and indentations of the object. Then try to transfer your tactile awareness into your painting. Imagine you are using searching strokes with your brush to caress the contours of the object as you paint it.

Another idea is to imagine you are extremely small and able to swoop along a line as you paint it, as if you are at one with the brush. Sometimes I do this when painting long curves. Occasionally, the feeling of travelling along a line I'm painting makes me feel excited or giddy – as if I'm on a rollercoaster. These physical feelings are real and can be very intense.

I've talked here about 'feeling' our work in a tactile, physical way, but feeling it emotionally can be just as helpful. So try to increase your awareness of how you feel about certain colours, shapes and patterns. Try on occasions to step outside your comfort zone to experiment with new things.

BE OPEN TO CHANGE

If you're doing an intuitive painting, you need to be completely open to paint whatever your inner artist directs. Think of yourself as a piece of thistledown blowing in the wind. If you think you know where the

painting is going, you probably aren't being open enough to your creative spontaneity.

It's perfectly possible, though, to plan a painting and then to 'hear' your inner artist telling you to change direction either a little or a lot. Sometimes I start a painting thinking I know what I'm going to paint, then as it progresses I realize I need to change my mind and perhaps even paint a new base coat over what I've done. This realization is emphatically not the same as a judgment or criticism. Rather, it's an intuitive knowing of what needs to be done. It's often best to avoid judging, criticizing or even interpreting our paintings as each can hinder creativity and even stifle our inner artist.

My advice is to think twice before completely refiguring a painting, because the reason you don't like it could have more to do with emotions that need to be acknowledged than with the original subject matter. I remember once spattering drops of paint all over an image of an island in the sea. I was angry with someone at the time. The individual took an instant dislike to the painting. Thinking it wouldn't matter if I changed it, I incorporated the drops into a new image so they were no longer identifiable. But now, when I look at the painting, I immediately remember the anger. I'm pleased I was able to express it this way rather than repress it. But I wish I hadn't tried to spare the other person by covering up my splatters!

Having said all this, I must add that it's not easy to change direction when using watercolours. Generally, if you decide you don't like the watercolour painting you're doing, you have to start again.

USE PAINT IN DIFFERENT WAYS
Don't be in awe of your paints. Instead, try experimenting by mixing unexpected colours, by applying it with knives, fingers, sponges, twigs or whatever, instead of brushes, and by applying it in thin washes (mixed with water or other solvent) or glazes (mixed with glazing fluid), or in thick swathes (called impasto).

When you choose each colour, consider exaggerating it - painting darker darks, lighter lights, brighter or deeper colours. Van Gogh helped himself to express his feelings in a very powerful way by exaggerating the colour of whatever he was painting and piling on the paint - sometimes even directly from the tube on to the support.

PLAY WITH PAINT
In Chapter Two we looked at how playing with paint can help us decide what to paint. But playing with paint can be beneficial in other ways too. Playfulness helps release creative energy, which encourages our inner artist to lead us down creative pathways that can make painting more exciting or fulfilling.

We've considered marbling and collage as two possibilities, but there are many others:

- Paint wet paper with watercolour paint, then tilt the paper to move the paint. This gives some beautiful effects and colour mixes

Island Trees, 2009

Strong emotion altered the early development of this painting (see above) and while there have been many changes since its first 'completion', it still seems unfinished to me!

acrylic on board, 60.5x31.5cm (80x24in)

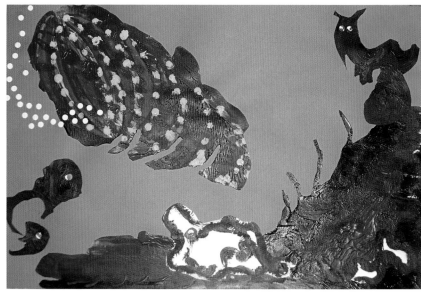

***Three Trees**, 2006*
***Red-hot Deep Sea**, 2006*
***Fantasy Garden**, 2006*

Cutting up sheets of paper annointed with thick gloopy paint in a class on 'playing with paint' (see page 135) enabled these three collages, as well as many others

above: *Three Trees, gouache collage on paper, 45.5x30.5cm (17¾x12in)*
top right: *Red-hot Deep Sea, gouache collage on paper, 30.5x45.5cm (12x17¾in)*
right: *Fantasy Garden, gouache and paper collage on paper, 30.5x45.5cm (12x17¾in)*

- Press crumpled cling-film (Saran wrap) over marks you've made, then remove it carefully when the paint is dry. This gives the marks a fascinating texture

- Apply acrylic paint to a very shiny card support, then drip on some solvent-based (as opposed to water-based) ink. This creates a marbled effect.

- Apply paint thickly and texture it with a stiff brush, a comb or a skewer. This can produce some wonderful 'geographical' effects

- With a dropper, drip a little white spirit ('turps') on to a painting done in water-based ink. This ink resists mixing with the white spirit, which can create some interesting effects

- Carefully suck up a little diluted paint with a drinking straw then gently blow the paint on to a support. This releases droplets and splatters of paint

- Incorporate metallic paint, sand, texture gel or gloss medium into your paintings. This can lead to a variety of fascinating effects

- Put a small painting in the deep freeze to see the effect on water-based paint or ink of extreme cold. This can create an interesting pattern

- Apply masking fluid to certain areas of the support, paint over the support then rub off the masking fluid. This reveals the pattern, design or random marks of the masking fluid

- Experiment by spraying a can of non-stick spray (sold for cake tins and baking sheets) randomly or in a design on to a primed surface, then painting over and around it

- Use part or all of a paper doily as a stencil. This produces a delicate pattern

- Lay tissue paper on wet paper, paint over the tissue with watercolour paint, and remove the tissue. This can leave a delightful pattern.

TUNE INTO YOUR SURROUNDINGS

As you go about your daily life between painting sessions, aim to be aware of your surroundings and of yourself in relation to your surroundings. Delight in what you see. You'll probably find that the more free your inner artist, the more observant and aware you become and the more heightened your enjoyment of the colours, shapes and symbols around you. Not only will this make it easier to choose subjects to paint (see Chapter Two) but it will also enrich you and enrich your input into your paintings. The same goes for events that occur around you. Being alert to what's going on keeps your artist's antennae in receptive mode.

'Art is what opens up the clogged pores of perception, what transmits the pulse of life.' (Frederick Franck; 1909-2006; artist and author)

Panda Surprise, 2006

*The delight on learning of my elder
daughter's first pregnancy provided
the energy for this explosively
colourful and fruit-filled work*

*acrylic and collage on canvas
48x40cm (18¾x15¾in)*

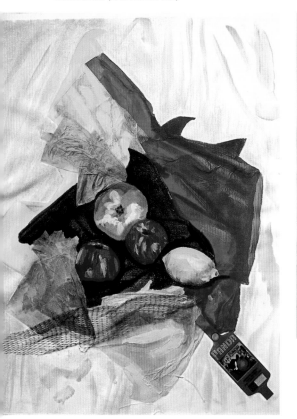

Picture-book Horse, 2006

*Streaky clouds made from tissue paper
initiated this windswept moorland scene, and
the grey Welsh mountain stallion, head and
tail aloft and nostrils flared, then seemed a
natural addition*

*acrylic and collage on paper
29.5x42cm (11½x16½in)*

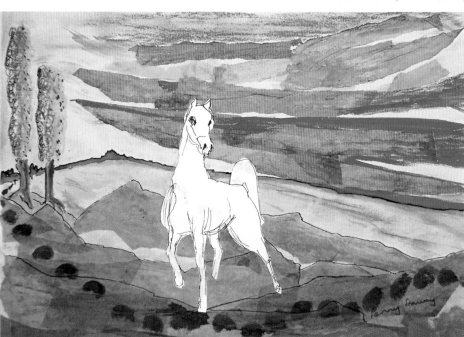

right: **Misted Mountain,** 2007

*The grain of different pieces
of wood suggests different images.
The idea for these jagged
mountains arose naturally from
this small panel*

acrylic on board, 23x23cm (9x9in)

> *'The artist brain is our child – it sees a fall forest and thinks, "'Wow! Leaf bouquet! Pretty! Gold-gilt-shimmery-earthskin-king'scarpet." It makes new connections.'*
> (Julia Cameron; born 1948; author)

All this came home to me when I was in my garden in West Cork some years ago, reading Frederick Franck's *Zen Seeing Zen Drawing*. A butterfly happened to settle on the page for a few seconds. This silent and unexpected event gave me great joy and seemed to connect me with the beauty, mystery and divinity of life.

This haiku of mine, composed just afterwards, sums up what happened:

Butterfly

A butterfly alights
on my page,
then is gone,
but changes all things.

INTERPRET COLOURS YOUR WAY

When it comes to interpreting the colours you see, remember there are no rights and wrongs. You can do it your way, so use the colours you think best represent the way you want to portray it.

> *'... instead of trying to reproduce exactly what I have before my eyes, I use colour more arbitrarily, in order to express myself forcibly.'*
> (Vincent van Gogh)

WORK WITH YOUR INTUITION

The use of intuition in painting is arguably one of the key features of 21st century art. When working with your intuition, the aim is to maximize what your inner self and the intrinsic nature of your subject have to offer, and to marry all this with what your developing painting itself has to offer.

As you begin a painting, let yourself be guided – partly or wholly – by intuition. If painting on a plywood board, you might take time to look at the grain with half-closed eyes and see what images it provokes in your imagination. By colouring in the markings and making the grain look obviously like the images you perceive, you are in effect 'releasing' these images from the wood, rather as the Renaissance artist Michelangelo (1475-1564) released his David from a block of marble.

You can also stimulate your intuition and imagination by sticking torn pieces of coloured tissue more or less at random on a support, then seeing what images are provoked by the

> *... 'terrible lucidity at moments when nature is so beautiful. I am not conscious of myself any more, and the pictures come to me as if in a dream.'*
> (Vincent van Gogh)

> *When painting a cloud, think like a cloud.'*
> (Steven Ross; artist and teacher, and son of the artist and teacher Bob Ross)

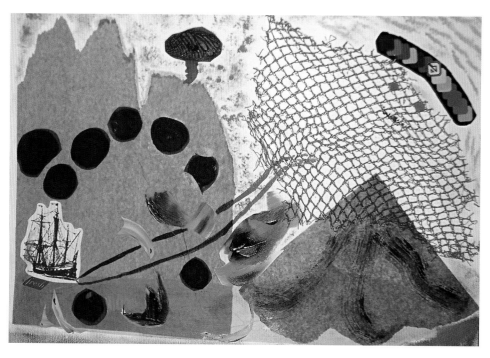

Smiling Ray, 2006

A few hours after I did this collage, the Australian TV naturalist Steve Irwin was tragically killed by a stingray near the Great Barrier Reef

acrylic and collage on paper 29.5x42cm (11½x16½in)

result. Another idea is to look at your subject, whether it's a person, object or scene, and aim to sense qualities that aren't immediately apparent. Looking at a person might induce you to recognize their inbuilt fortitude or compassion, for example. You might then want to incorporate that recognition into your painting, for example, by magnifying certain facial features or bodily characteristics that suggest those qualities, or perhaps by adding things to your painting that symbolize those qualities. Be open to the images and ideas that flit through your mind as you paint, or as you look at your work between sessions. These might result from intuitive connections from deep within your unconscious memory and may be well worth incorporating somehow into your painting.

Yet another idea is to take the time to sense the 'is-ness' of whatever object you are painting, so as to be more sensitive to its nature and therefore more able to represent it in a way that is truly revealing. As an example, on recognizing the fragility and playfulness of a kitten, you could emphasize these features in your painting.

Finally, be on the lookout as your painting develops so what you've done can itself stimulate your intuition.

> *'A painting has a life of its own. I try to let it come through.'*
> (Jackson Pollock; 1912-1956; abstract expressionist/action painter)

GO BEYOND YOUR COMFORT ZONE

It's all too easy for artists to get stuck in a rut and continue to produce much the same sort of painting year in, year out. This isn't the best use of their creativity.

There's nothing that the inner artist likes more than a new challenge. So try, on occasion, to push yourself beyond your comfort zone by painting in a different way – perhaps by using different types of subject, media, brushes or supports. Take stock at intervals while painting and consider whether you are simply producing something much as you have done before. Ask yourself whether you could take a risk by doing something differently. It can feel fantastic to leave your comfort zone and you may well then find that working with free-flowing creative energy lets you produce new, unexpected and exciting work.

USE DREAMS AND MARVEL AT PROPHECIES

As you paint a picture with the help of your inner artist, your unleashed creative energy may stimulate your unconscious to make you dream more, or more vividly, than usual. Try to make the time on waking to recall your dreams and then to write them down immediately in a special 'dream notebook' kept by your bed. If you don't bother to recall and note them down, you're very likely to forget them.

While freed creative energy can stimulate dreams, these can, in turn, enrich creative energy and thereby even change the content or style of your painting.

When painting, you may sometimes like to recall recent dreams to see if they influence your creative flow. Or you might like to encourage yourself to daydream by entering a semi-meditational state in which you let your mind wander where it will.

> 'Allow oneself to dream while painting.'
> (Paul Gauguin)

Sometimes paintings seem to be prophetic. My sister, Jenny Hare, recounts how one day she spontaneously painted a surreal picture that clearly depicted one of her horses hovering in the air above the moon on which Jenny was standing. The horse was a beautiful ex-racehorse with the stable-name of Queenie. Jenny had spent countless hours gentling and rehabilitating her. And they'd become soulmates. The day after doing the painting, Queenie died after a freak accident. In her grief Jenny was comforted by the thought that Queenie was saying

Dream Time, 2006

On waking from a vivid dream, I felt compelled to paint it. I also 'knew' that the 'tepees' were actually the nose-cones of rockets which had sunk, tail-down, in the ground. The rocket in the sky is flying very slowly towards the hole in the mountain and will end up tail-down in the ground

acrylic on board, 60x48cm (23½x19in)

Three Birds, 2006
Fox by the Moon, 2006

Two collages done with pieces of paper painted during a 'playing with paint' class (see page 135)

above: *Three Birds*
acrylic collage and acrylic on paper
29.5x42cm (11½x16½in)
right: *Fox by the Moon*
tissue and gouache collage on paper
30.5x46cm (12x18in)

goodbye to her in the painting and letting her know that all was well in her next life. The painting seemed to predict her beloved Queenie's demise.

RECOGNIZE HOW MEMORY AFFECTS CREATIVITY

Researchers identify three ways in which individuals memorize things:

- Visual – inputs via the eyes

- Auditory – inputs via the ears

- Kinaesthetic – inputs from our bodily movement and position.

We all memorize things in some combination of these modes but most of us remember better using one in particular. I remember things best if they're associated with a kinaesthetic input. When trying to remember which turn to take by car, I'm influenced as much by the memory of the inclination of my body as by visual cues. I'm also better at remembering information I've read than things people tell me!

I have a hunch that our creative energy may run more freely when we tune in to and indulge our favoured type of memory input. When I'm painting, my most creative times are when I'm either actually moving or moving in my imagination. I might be painting a merry-go-round and remembering the swirling move-

ment, or I might be depicting a mountain and sensing the vertigo associated with looking down from on high. Whatever, the powerful physical sensations impel me to recreate them in my painting and enable me to go further and deeper than I might otherwise have done.

This experience may be akin to that of painters of a new approach to abstract painting which began in Europe and the US in 1950 and is known variously as abstract impressionism, abstract express-ionism, tachisme, aformalism, and metavisual or informal art. An artist of this persuasion begins painting without knowing what to paint. Their subject becomes apparent only as they manipulate the brushes and paint and incorporate motifs and symbols drawn from experiences and realizations stored in their unconscious. Presumably the acts of standing at the easel, wielding the brushes and looking at the resulting marks trigger both visual and kinaesthetic memories which then help guide their further actions.

FIND YOUR STYLE

Each of us, when asked to paint a particular subject, will produce a unique painting. What contributes to making our style unique includes our personality, memories, intellect, technical ability, training, exper-ience, physical and creative energy

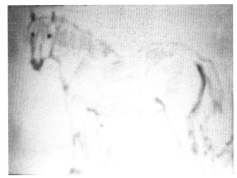

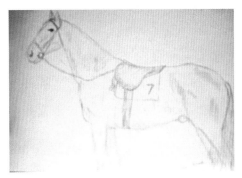

Dream Boy, 1958, Horse – 1, 1959, Horse – 2, 1959

As a horse-mad teen, my copious drawings of horses crystallized my delight in stroking, grooming, talking to and riding these wonderful animals

above: *Dream Boy, pencil on paper, 8x15cm (3x6in)*
top right: *Horse – 1, pencil on paper, 12.5x18cm (4¾x7in)*
right: *Horse – 2, pencil on paper, 12.5x18cm (4¾x7in)*

levels, colour preferences and emotional state (which is itself based on both our conscious and unconscious feelings).

Some artists always paint in the same style, making it immediately recognizable. Others change their style throughout their life. What's important is to discover the style or styles that best suit you, your ability and your personality. One way of doing this is to try out different styles by copying the paintings of well-known artists, and to see whether any particularly take your fancy. Another is simply to let your style evolve over the weeks, months and years. It's just as important to let your style evolve if you mainly paint in a representational way as it is if you paint abstract or semi-abstract pictures. Otherwise you might just as well take a photograph. What we like so much about the great artists is their style. It shows they have personality, opinions, choices and feelings. It makes them human and draws us to their work.

As we look back at the life experiences of well-known artists, it's often possible to see how these have influenced the style of their artworks.

Your life and your style

When you've been painting for some years you might find it interesting to look at your paintings in sequence and note the development – including any major changes – in your style. You may then be able to ponder whether this has accompanied or followed changes in your personal circumstances. When I do this I find my pictures reveal much more about me than I realized at the time.

USE ENCOURAGEMENT, AFFIRMATION AND PRAISE

We can increase our confidence and even change our painting behaviour either by giving ourselves encouragement, affirmation and praise, or by accepting it from others – even if we have to ask for it first. Encouragement puts courage – or 'heart' – into us, making us feel warm and heartened. Affirmation highlights our strengths and achievements and firms up our belief that we are approved of and loved. And the right sort of praise helps us believe in ourselves.

London Plane Bark – 'Running Deer', 2009

Few people realize at first that this picture represents tree bark – and some very clearly see a deer in motion – but I nevertheless get a lot of positive feed-back

acrylic on board, 83x61cm (32½x24in)

But psychology researchers say that praise comes in two types, descriptive (which describes the work) and judgmental (which criticises it). Artists mainly need the former.

To give descriptive praise:

- Focus on what you or someone else is doing or has done

- Describe it in detail and aloud

- Recognize the positive emotions the artist gets from what they are doing

- Name these emotions.

If a young child shows you their painting, you could say, 'You've painted a tree with a nest in it, some yellow flowers in the garden, and a girl on the swing with a big smile that makes me feel happy'. This describes what the child has painted and how it makes you feel, and mainly uses 'you' language. What you ideally shouldn't give is judgmental praise, like, 'I think the tree is painted very well'. This sort of praise is based on your opinion and uses 'I' language.

Descriptive praise centres on the 'praisee', makes them feel 'heard' and most important, validates their efforts and encourages them to paint more. In contrast, judgmental praise centres on the 'praiser' and leaves the praisee feeling strangely out of it and disconnected from what they have done. Of course, this leaves the praiser open to contradiction. You might make a positive comment you think describes someone's work, only to be told that this wasn't what they'd intended at all. Be respectful and gentle as they say what they did intend.

It's important not to confuse draughtsmanship with art. Just because someone can't accurately depict a cottage doesn't mean their attempt is useless. You can always find something positive to say about their effort and about the 'cottage-ness' of the piece. When novices ask for an opinion they're not looking for a gallery curator's eye-view. They probably know all too well they're not a great artist. The smallest thoughtless remark could set them back weeks or even totally destroy their fragile confidence.

Different people's perceptions of their work can give experienced artists a huge thrill. This is especially true of abstract subjects that can please each viewer in a unique way. As your confidence builds you'll become more at ease with putting yourself on the line. But always keep it in perspective and don't get downhearted. One artist I know jots down the thoughtless or downright derogatory things people say about her work and laughs about them instead of crying!

Of course, when we view other people's work, we decide very quickly whether we like it or not. But that is our own business. So if an artist invites you to comment on a painting they have done, it's wise to use descriptive praise if appropriate, or perhaps to ask questions about it rather than volunteer judgment.

'You do it and nothing happens and you do it again. But there's always the possibility that you might do something marvellous and totally unpredictable and surprise yourself.... And how can one be luckier?'
(Frank Auerbach)

Similarly, when viewing your own work, look at it carefully, see how it makes you feel, then describe it to yourself with descriptive praise. Sometimes such praise helps an artist discern how to alter the direction of a painting or, perhaps, do things differently in a new painting. Adverse criticism, however, is generally counter-productive.

> '...lack of corporate spirit among ... artists, who criticize and persecute each other, fortunately without succeeding in annihilating each other.'
> (Vincent van Gogh)

DISTINGUISH YOUR INNER CRITIC FROM YOUR INNER EDITOR

If we learn to recognize the voices of our 'inner critic' and 'inner editor', we can choose who we listen to. Our inner critic is that part of us that invariably disparages our work and is perfectly capable of rubbishing it so much that we won't want to continue. Our inner editor, on the other hand, points out what needs doing, but does so in a positive, constructive way.

Clearly it's useful to have your inner editor's advice to hand, but entirely counterproductive to have your inner critic muscling in. So aim to distinguish between the two voices.

Paua Shell – stages 1-3, 2009

I often love, delove, then relove a painting at various stages, so I remind myself not to be disheartened before it is finished

acrylic on board
60x49cm (23½x19¼in) x 3

VISIT GALLERIES, EXHIBITIONS AND OPEN STUDIOS

My experience is that it's more stimulating to the senses and provocative of ideas to visit galleries, exhibitions, and open studios when my own creative energy is flowing and I'm doing a lot of painting, than it is when my creativity is going through a quiescent or resistant stage. Looking at other people's work can raise our sights, make us inquisitive about technique, and heighten our emotional sensitivity. It can also enrich our awareness of what we are doing in our own painting and provide ideas for new directions.

A frequent realization I have at exhibitions or shows is how the paintings I like best are often much simpler than my own. Even today, I often mistakenly believe that a painting should be complex to be pleasing. I need reminders to aim to

> *'When I look at other people's paintings I learn something about my painting.'*
> Hughie O'Donohue; born 1953; artist)

depict my own ideas with creative simplicity.

BE PATIENT

It's easy to become so impatient with the progress of a painting that we imagine too soon that it's finished, then discard it prematurely or, worse, paint over it. Coming to a premature conclusion usually reflects an artist's inexperience, because over the years the more we paint, the better we come to realize that each painting progresses through several stages before we should deem it 'complete'. The important thing is not to become so disheartened at any stage that we give up.

Remember that each layer of a painting makes its own important contribution, so don't be tempted to rush the process. Remember, too, that it's often only obvious that a painting has come into its own during the very last few brush-strokes.

It's a good idea to photograph your work at various stages as it progresses. Once you've done this with a few paintings, you'll realize that although you could, perhaps, have finished at an earlier stage, the

> *'If we are worried about losing our place to somebody more talented, we've already lost it.'*
> (Julian Schnabel; born 1951; artist and film-maker)

final result is often much more gratifying if you keep going.

Sometimes artists resist making changes or going deeper into their work. Try to listen to yourself and follow your deepest desires and emotions via your work. My sister, Jenny, knows a painting is going the way she wants when the horse or other subject appears real: 'If I want to stroke a horse, or breathe into its nose, I think it's real', she says. I feel much the same in that if I'm painting an apple and suddenly realize it looks so good that I want to eat it, I know that that part of the picture at least is done.

Bide your time and keep returning to look at a painting every few days, weeks or even months, if you're unsure whether or not it's finished. Many artists – such as Matisse – find that turning their work to the wall for some time, then looking at it afresh, helps them decide how to

 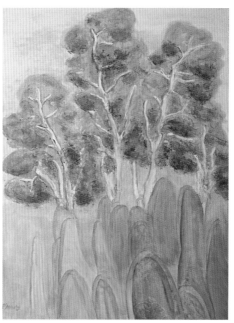 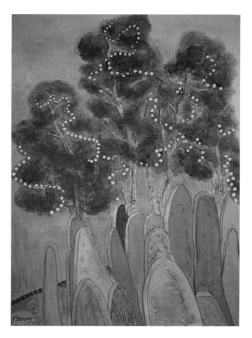

Do not stand at my grave and weep – stages 1-3, 2010

I revisited this painting on and off over six months. It was only when I'd added strings of fairy lights to the trees that I knew it was complete

acrylic on board
82x60cm (32¼x23½)

take things further. One day you'll know what more needs doing, if anything, and one day you'll know when it's done.

> *'I never think I've finished a nude until I feel I could pinch it.'* (Pierre-Auguste Renoir; 1841-1919; early impressionist artist)

SIGN YOUR PICTURE

When your painting is finished to your satisfaction, take a fine brush and some suitably visible paint and add your signature. If you're intending to frame the piece, leave a little space around your name so it doesn't get covered up by frame or mount. Take time to decide how you want your name to appear and practice writing it with the brush on another piece of scrap paper, canvas or board. Some artists use a little motif instead of, or as well as, their name: James A M Whistler (1834-1903) used the motif of a small butterfly, while John Kingerlee (born 1936) uses a man in a boat. The choice is yours.

Lastly, add its title, date and dimensions to the back of the painting, either directly or on a sticky label.

Next we'll see how to care for our finished creations.

Chapter Five – Caring for your Creations

Being an artist is a little like being a gardener in that having an idea for a painting is like selecting a seed; preparing a support, paints and brushes like preparing a seedbed; making the first marks like watching tiny leaves unfurl; painting a picture like nurturing a young plant; and enjoying, showing, giving or selling paintings, like harvesting, using and getting pleasure from flowers, fruits and other produce. Just as some gardeners are better than others at certain stages of the plant-husbandry cycle, so, too, some artists are better than others at certain stages of the creative-art cycle. 'Harvesting' and allocating their produce is a stage many artists find so challenging that some avoid it completely. If this is a problem for you, the secret is to take your inner artist by the hand and, together to learn how best to proceed.

Harvesting our creative output requires several diverse skills and abilities. First, we need to take time to look at and, hopefully, enjoy a new painting. Next, we have to decide what to do with it.

LOOKING AT AND AFFIRMING YOUR WORK

When you start to assess a new work, look at it intensely so you really engage with it. Then affirm what you've created. Each creation merits your interest and approval because it's unique and done for

Fire Mountain 1-3, 2005

It was exhilarating letting my brush and imagination work together to pick out images of mountains from within the grain of the plywood support. Adding colour and a little gold leaf gave each image its own particular atmosphere and character

left to right: *Fire Mountain 1, acrylic on board, 11x11cm (4¼x4¼in)*
Fire Mountain 2, acrylic on board, 14x14cm (5½x5½in)
Fire Mountain 3, acrylic on board, 14x14cm (5½x5½in)

Fire mountain 4-5, 2005

left: *Fire Mountain 4, acrylic on board,*
20x14cm (8x5½in)
above: *Fire Mountain 5, acrylic on board,*
80x60cm (31½x23½in)

particular reasons at this particular stage of your life as a human being and as an artist.

Unfortunately, too many artists are over-critical of their work, judging it against other paintings they or others have done. Anyone can look critically at a new work and say what's wrong with it.

What's important, though, is to affirm what is right. When reading one of Rolf Harris's books (*Rolf on Art*) I was struck by how frequently he said what he liked about each picture. His is a refreshing outlook and one that would be helpful for everyone. Affirmation of what you like about a picture can enrich your understanding of what you have created and make you more aware of your positive attributes as an artist. I believe a lot of artists smother the fire of their creativity with a cold blanket of negativity. Our inner artist is like a child in that it blossoms and flourishes with warm descriptive praise and withers with harsh unthinking invective.

Take time, too, to reflect on what a new work may reveal about you and your needs and aspirations, joys and concerns, because something in it may crystallize or highlight where you are in your personal development.

As you look back over your body of work, consider your journey so far. Assess whether your skills are expanding and whether you are homing in on a particular style. If you notice obvious changes in your choice of subject matter and ways of painting, ask yourself if these might correlate with changes or even with paradigm shifts in your views on life.

If you are especially drawn to a picture, you might decide to paint others that are similar, so as to create a series. It isn't necessary to have a completely different subject for each new picture. It has been argued that greater depth of style and painterliness can be achieved by enhancing one's skills by painting the same subject differently as opposed to chopping and changing style, medium and subject. This is obviously open to debate.

BUILDING A PORTFOLIO

Many artists store and display what they have done by keeping their paintings in an artist's portfolio.

Art students in particular keep much of their work in portfolios. A portfolio is a portable storage and display system bought from an artist's supplier or a stationer, or over the internet. Basically, it's a large, slim case that's made of leather, plastic or cardboard and has a handle. Inside there are ring clips to hold plastic sleeves into which go artworks alone, or backing paper on which to affix artworks each side with PVA glue or a reusable adhesive (such as Blu Tack). Many portfolios come with plastic pockets and additional pockets can be purchased if necessary. Some people simply keep paintings loose inside a portfolio. To make it easier to use a portfolio, label the front of the outside so you know which side up it goes, and avoid filling it so full that it becomes unwieldy or overly heavy. This label could also detail the contents, for easy reference.

Commercially available portfolios come in different sizes but very large paintings won't fit in even the largest. Instead, these can be protected in wrappings of acid-free paper or cardboard and stored flat on the floor – perhaps under a bed.

Blood Orange Jelly, 2006

This page includes four photos of photos of a champagne flute of jelly, plus two paintings, the upper of which is the more painterly

Portfolio page, photo

STORING DIGITAL IMAGES

It's an excellent idea to store digital photos of all your artworks on computer. A photo-management package enables you to create an entirely electronic portfolio. This can be an easy way of showing your work to friends, family and, perhaps, even to teachers, agents, gallerists or prospective purchasers. Back up photos by storing them on an external hard drive or a memory stick or CD, or by uploading them to a web album.

Storing paintings digitally makes for vastly easier transportation than does using a portfolio. Another advantage of a computerized store is that it's easy to do further work on the digital images, or to create a very professional-looking record in the form of a photobook by emailing photos and captions to an on-line printing company. For the best options and deals, enter 'photobook' into your search engine and compare the results.

Another advantage of storing paintings digitally is that you can view them on screen at any time. You can also edit them, email them to other people, insert them into letters, and print them out. High quality original digital images can be used to produce full-size prints that can be framed.

Take advice before you buy a camera to use for photographing paintings, but note that it needs a resolution of no more than four or five megapixels unless you're planning to enlarge images until they are bigger than the original paintings. A pixel is a dot on a screen. A one-megapixel camera produces images containing one million dots on a screen, a five-megapixel camera produces images with five million dots. The more megapixels in an image, the better its 'resolution', meaning the clearer and sharper it is, and the larger the print you can produce.

When photographing paintings:

- Ideally, take photos without flash and in natural daylight – either outside on an overcast day, or inside in bright indirect daylight. Alternatively, take photos in the 'ordinary' electric light from a tungsten filament bulb; modern cameras can automatically correct the resulting colour distortion

- Put your camera on a tripod. Holding a camera inevitably causes camera shake, however steady your hand or modern your camera. Also, the lower the camera's resolution, the more noticeable blurring from any camera-shake will be. This

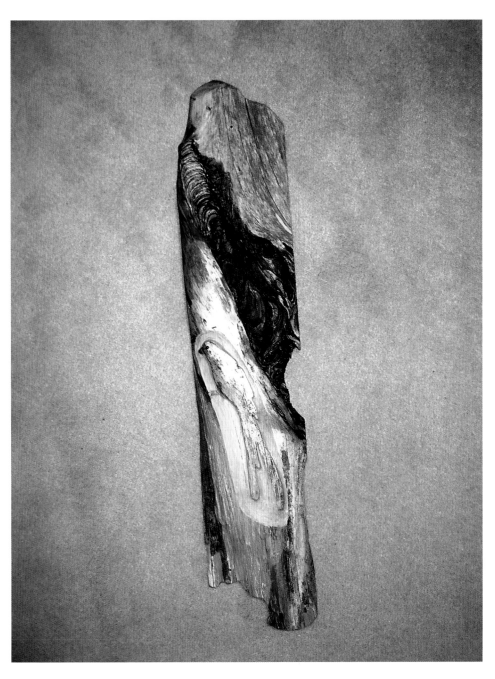

becomes more noticeable (and annoying) as you enlarge a photo

- Direct the lens squarely on to the painting in each plane by adjusting the tripod. Alternatively, put the painting on the floor, and with a small mirror (such as a woman's handbag mirror) in its centre, stand over the painting and direct the camera until you see an image of its lens in the centre of the camera screen. This means the lens is perpendicular to the painting and the image it records won't be unnecessarily distorted

- A wide-angle lens will reduce image distortion

- If a painting is behind glass, it's best to remove the glass as this avoids capturing reflections from

Scissor-tailed Flycatcher, 2005

I carved this little bird into a beautifully marked piece of yew during a workshop given by the master wood-carver, Ben Russell, in Kealkil, County Cork. Part of the wood was silvery and just right for the wings, while a tiny ball of ebony made a compelling eye

photo

***Daddy Watching Television**, 1959*

This sketch has been stored for 50 years but has the power to bring back clear memories of my father sitting in a characteristic cross-legged pose by the fire

pencil on paper
25.5x18cm (10x7in)

the glass. Alternatively, clean the glass well first, then either take photos in bright natural light (as a flash creates a bright spot of reflection), or illuminate the painting with two bright electric lights, one from each side. If your lens can take a polarising filter (which is most likely with a single-lens-reflex camera) this will greatly help reduce glare

- Try scanning a small painting on to your computer instead of photographing it. The result is often clearer and the colours more accurate. Scanning may not be as good for faint pencil drawings, though.

STORING ARTWORK

It goes without saying that paintings themselves should be kept in suitable conditions that are dry and safe and won't distort the support or damage the paint. Varnish helps protect oil and acrylic paintings. Pastel-fixative spray prevents the loss of pastel powder but tends to deepen the colour of pastel pigments and also to change the appearance of the surface by making it look less powdery. One way of storing paintings is to keep them in a drawer or on a shelf. Plan chests are the very best thing – which is why galleries and museums use them - but they are expensive and take up quite a lot of space. Keep

paper or other supports separate using sheets of acid-free paper and good strong protection, if necessary.

It's wise to get into the habit of labelling each painting on its back before you store it. Include both its title and the date. If you are storing your child's artwork, put either the date or the child's age, and if you have more than one child, put the child's name too.

If you have a large number of framed paintings, boards, or canvases on stretchers, and insufficient storage space at home, your options are to put them into a store, give them away or sell them.

FRAMING

By having a picture framed, an artist makes the statement that they consider the work worth framing. This might be as much because the painting represents something important to them as because they think it's worthy of showing. A well chosen frame can make a painting look more special and important. It attracts attention by focusing the gaze on its contents. And it can enhance (or detract from!) a painting. The size, colour and style of a frame are all important and it's well worth taking plenty of time and, if necessary, advice, to choose the right one. Make time to involve your inner artist in the choice so the frame becomes an intrinsic part of the creation. There are several ways of arriving at a framed picture:

Professional framing

This is expensive: the cost varies according to the framer, your geographical location, the size of painting, and the size and complexity of the frame and any mount you choose. Framing costs twice as much in some areas of the country compared with others. If you were to paint and frame one picture a week you could spend thousands of pounds a year on framing.

Doing it yourself

This requires equipment such as a mitre-saw and a sander that cost money and need storing, as well as the skill and time to use them. Also, framing material is sold in pre-allocated lengths, so some is inevitably wasted. I reckon DIY framing costs about half that of professional framing, in a city at least.

Buying a ready-made frame from an art shop (buying from a catalogue or on-line is also a good idea).

Buying a framed picture or mirror at a discount household store, or even at a second-hand shop. You then remove the existing picture or mirror, paint your painting on its back, then replace it in its frame. But you must like the frame, and the painting should suit the frame rather than the other way around.

Another option is to paint on a board or a box canvas (one that's stretched around a simple frame so it's on show at the sides) which can be hung without being framed. Some people choose to frame box canvases, though, by putting them

Witch 1, 1958
Witch 2, 1958

A child's imagination can elicit powerful images. These childhood drawings remind me how scared I was that a witch or a bogeyman was hiding behind the curtains in the bedroom I shared with my sister

far right: *Witch 1, pencil on paper, 20x18cm (8x7in)*
right: *Witch 2, pencil on paper, 26.5x20cm (10¼x8in)*

on a 'tray' with a gap between the edges of the box canvas and the internal edges of tray all around.

HANGING

A new painting is rather like a baby in that we want to keep it safe and near to us. But just as we need to give a child wings as he or she grows, so too do we need to let our paintings 'fly'. Hanging a painting generally makes it easier to let it go, perhaps because it seems then to become an object in its own right, rather than an extension of ourselves.

SHOWING OTHERS

There is of course absolutely no need for an artist to show their work to anyone. Each work you do is special and important in some way, whatever anyone else thinks. Yet showing invites judgment, interference, criticism, advice, subjective opinion, and even jealousy, envy or competitiveness. All too often little of this is rewarding or constructive. However,

most artists do decide to show their work to others. This can be beneficial provided they have the resilience to shrug off any less-than-positive comments.

> 'Treat your work as a dealer would – as something special, rare and important.'
> (Christopher S Middendorf; born 1952; gallerist)

Show your work at home, in a studio, at an exhibition, or in a gallery, shop or other outlet. In a sense an artist is at their most vulnerable when showing their work in their home or studio. A sensitive viewer is aware of this and doesn't volunteer comments that could in any way be hurtful. Having paintings on view in a public exhibition, gallery, shop or other outlet is easier because the viewer needn't worry about grooming their response and the artist is anyway unaware of their reaction.

Yellow Rose, 1959
Fuchsia, 1959

A child's artwork doesn't take up much space and is well worth storing, just for old time's sake. I'd completely forgotten ever doing these paintings until I unearthed them from the bottom of a box more than 50 years after doing them

each poster paint on paper, 38x28cm (15x11in)

In a sense, showing your pictures is rather like showing your homes to prospective buyers. People often have strong feelings about pictures and houses. So it's often easier for someone else to show your picture, or for an estate agent to show your home.

Many artists become less sensitive to other people's views as they mature and enjoy success. They come to accept that people have different tastes, different needs and different emotional reactions. But sensitivity is often a hallmark of the creative spirit and developing too thick a skin can be counterproductive to working with your inner artist.

My way of behaving when people see my paintings in my home is to volunteer nothing unless asked. In this way I don't 'show' my paintings as such, but if people want to engage with me about my work, that's fine, and I hope and expect they will either be positive or say nothing. That's not to say I never invite comment, because I do … but from people I trust not to rubbish what I've done. I think the heart of all this is that a new creation feels like a part of me, so if someone says something adverse, it feels as if they are doing so about me. However, after a picture is framed and hung, the feeling of 'love me, love my picture' evaporates ever faster. Perhaps the way viewers should be

HOW TO COMMENT CONSTRUCTIVELY ON AN ARTWORK

You don't need to say anything, but if you want to make constructive comments here are my top three suggestions:

- Observe carefully what the artist (who may be you!) has done

- Describe it (the work – not your reaction) in detail

- Recognise and name any emotions or memories you get while looking at it, or any emotions you think the artist may have had while doing it.

'It seems to me…' is a good opening phrase. If what you say about the artist's emotions is correct, they'll say so and be pleased you've picked up on it. If you've missed the point, they'll tell you. What's especially interesting to me is when commentators see things I never consciously intended. It's especially fascinating when many such individuals come up with similar comments or interpretations. This can be a valuable source of insight.

when with an artist and their new painting is as they would be with a newly-delivered mother and her newborn baby. They would 'tread softly' and be gentle, gracious and loving in their comments. I remember a mother hamster that I had as a child eating her babies when inadvertently disturbed. I guess many an artist has destroyed a new painting in response to criticism from others or, indeed, themselves.

Belonging to an art society and showing your work at its exhibitions is the easiest way for most artists to get their work seen. The costs of membership and of 'hanging fees' are minimal. There is none of the hassle of putting on an exhibition of your own. And if, like many artists, you want to show only one or two pictures a year, this is what works best.

Commercial galleries are generally not interested in showing the work of artists unless they are serious professionals.

UNWANTED PAINTINGS
Artists throughout the centuries have painted over unwanted images so as not to waste good supports. My

advice is not to do this too quickly, because it's often possible to continue working on a picture until you produce something you do like. Sometimes, too, a picture gets destroyed because it represents something emotionally important yet currently unacceptable to an artist. In other words, the image may have come undiluted and unexplained direct from their unconscious. One day you may be able to accept it as a useful or even important part of your work.

> '... you feel good when you hand something to someone that you made and they get something out of it. It's a pretty magic place to be.'
> (Richard Shaw; born 1941; ceramicist)

GIVING PAINTINGS AWAY

Among the options are to give your work:

- As a present to friends or family
- As a thank-you
- To someone who's admired a particular piece
- To a charity auction.

Whether you've given away or sold a painting, it's a lovely feeling to see it on the wall of someone's home. What's not so great is to give someone a painting only to discover some time later that they still haven't put it on show! Giving away your work is a very vulnerable act.

SELLING PAINTINGS

It's challenging, to say the least, to become a professional artist in the sense of one who makes a living from selling paintings. Having said this, many artists who make only a very small income from their work still call themselves 'professional'. But the vast majority of artists remain amateurs in the sense that they paint because they love it, and may or may not sell any paintings. In the final analysis, at what stage

Lily, 1959
Catkins, 1959

right: *Lily, poster paint on paper 51x39cm (20x15½in)*
far right: *Catkins, poster paint on paper, 51x39cm (20x15½in)*

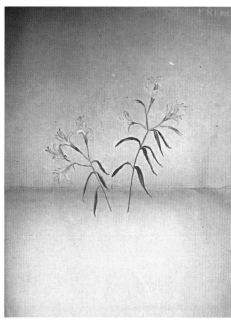

Daffodil, *1959*
Golden Rod, *1959*

far left: *Daffodil, poster paint on paper,*
38.5x28cm (15x11in)
left: *Golden Rod, poster paint on paper,*
51x39cm (20x15½in)

you put 'artist' on your passport is up to you!

The likelihood of selling work depends on many things, including the:

- Skill or 'talent' of the artist
- Eminence of the artist (many people are like sheep in seeking to be part of a 'club' that includes others who value a particular artist)
- Collectability of the work (how likely its value is to increase as part of the 'art market')
- Attractiveness of the work (how immediately appealing it is – even, perhaps, as a decorator item)

- Unusualness of the work (the thrill of the new always invites comment)
- Subject (certain subjects invariably sell well, such as cats, seascapes, boats)
- Size (small paintings are more likely to fit in most people's homes, so have a bigger potential market)
- Networking (gets people talking and thinking)
- Exhibiting in galleries, shops or on-line (to show potential buyers)
- Other marketing
- Quality of an agent, dealer or gallerist (note that a gallerist takes at least 30 per cent of the achieved retail price of a painting

'Many successful artists prefer to represent their own work and arrange their exhibitions.' (Tennyson Schad; 1930-2001; gallerist and intellectual property attorney)

– and often 50 per cent or more)
- Current fashion in the art world
- Zeitgeist (the 'spirit of the times')
- Hype
- 'Emperor's new clothes'
- Readymade market among those who already collect pieces by a given artist.

If you have an exhibition or an open studio, you may think it's a good idea to sell greetings cards made from photographs of your paintings. If you do this, always remember to print your name and contact details, together with the title of the work, on the back of the card. This way, someone who loves your work but can't afford to buy a painting can leave with something in their hand. Who knows, from sticking it on their fridge they might come back for a real painting one day.

If you'd like to know more about how to sell your work, a good place to start is, *The Artist's Guide to Selling Work*, by Annabelle Ruston (published by the Fine Art Trade Guild).

OTHER OUTLETS FOR YOUR INNER ARTIST

Once you begin working with your inner artist, you'll probably find yourself being more creative than before in many other areas of your life, such as clothes, gardening, writing, interior design, or photography.

We've looked at how to involve your inner artist in the practicalities of painting (Chapters One and Two), deciding what to paint (Chapter Three), creating art (Chapter Four) and, here, in caring for your creations. Now let's see how keeping an art log can magnify the progress you and your inner artist make together.

Chapter Six – Your Personal Art Log

A personal art log records all kinds of thoughts, feelings and observations that come from art classes or other painting sessions. Keeping such a journal can be astonishingly helpful in many ways. It can magnify the pleasure you get from painting and encourage you and your inner artist to move forward together. It's fascinating how writing and painting go so well in tandem – as you get into the habit of writing your notes you may well find yourself wanting to paint more and more.

There are several ways of writing and keeping a log. What's best is whatever turns out to be most practical and right for you. Entries can be handwritten, or composed and printed on a computer. Choose whichever method you think will make keeping your log easiest for you, so you don't cop out of or delay doing updates. It's helpful to keep a notebook handy so if you have some thought, feeling or insight you'd like to include you can jot it down at any time, wherever you are, ready to add to your log later. I keep a notebook and pen by my bed as I often find that ideas and inspirations come to me in the middle of the night or the early morning, sometimes on waking from a dream.

You may decide to keep your log entries plus associated paintings (or copies or photos) in a portfolio. Or you could store, display and edit your log and associated artworks entirely on a computer.

STORE YOUR LOG IN AN ARTIST'S PORTFOLIO

Inside the plastic pockets of an artist's portfolio you can insert paper or card on to which you stick log entries by the relevant artworks. But a portfolio offers a myriad of possibilities other than simply housing your log and paintings. You can insert photos of well-known artists' work to illustrate particular points. You can choose backing sheets of different colours. You can draw on a backing sheet to illustrate links between pieces of work. And you can record the progress of your work by sticking on to backing sheets small photos of paintings you've done. It can also be interesting and helpful to retain photographic references or sketches that have influenced a particular piece of work.

Aim to be creative in the way you display your work and any additions. In effect, you are telling the story of your creative development as an artist, so each entry is like gold dust.

It's well worth reflecting on each piece of artwork that you insert in your portfolio. You might, for example, notice that several pieces done in succession are more primitive than ones done before or after. Instead of decrying them or even throwing them out, you might ponder on whether your inner artist influenced your work in that way to bring you back to basics and stop you being unnecessarily detailed and 'prissy'. Your inner artist is a good friend who never pretends.

> 'Painting is just another way of keeping a diary.'
> (Pablo Picasso)

COMPUTERIZE YOUR LOG

Another option is to keep your art log, along with photos of your artworks, on a computer. You should also save your log entries and photos on to a memory stick, CD, or external hard drive to provide backup in case your computer fails.

SPEAK FROM YOUR HEART AND GUT

When composing your log, try to speak from your heart, gut, and 'right-brain' (the brain's intuitive side), rather than just from your

Never-ending Loop, *2005*

This portfolio page shows nine photos of my clay model, 'Never-Ending Loop', plus a quick painting in three colours and my log

portfolio page, photo

Never-ending Loop plus Apple and Eggs, *2005*

This portfolio page shows three more photos of the 'Never-ending Loop model', plus the next week's painting, 'Apple and Eggs', and my log

portfolio page, photo

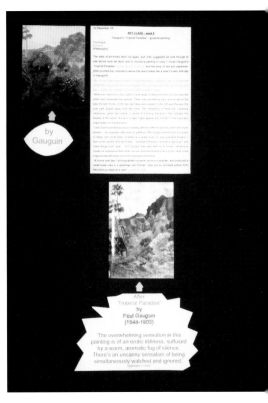

Poppy Pistol, *2005*
Circus acrobats, *2005*
Tropical Paradise, *2005*

These portfolio pages show, with their respective logs, how my 'Poppy Pistol' painting was inspired by the lipstick in my 'Mouth' drawing and by the shadows in my 'Never-ending Loop' model; the photo source of my 'Circus Acrobats' painting, plus a geometric impression and a quick drawing; and a photo of Gauguin's 'Tropical Paradise' plus my rapid copy

left to right: *Poppy Pistol, Portfolio page, photo*
Circus acrobats, Portfolio page, photo
Tropical Paradise, Portfolio page, photo

Easels in Mirror, 2006
Fruit and Vegetables, 2006

The 'Easels in Mirror' portfolio page shows a small photo of the charcoal sketch, a fellow student's sketch of how to make an easel, a webpage depicting easels, plus my log. The 'Fruit and Vegetables' page includes a progression of five photos of pictures done with differing media, plus my log

right: *Easels in Mirror,*
Portfolio page, photo
far right: *Fruit and Vegetable Pics,*
Portfolio page, photo

'left-brain' (its intellectual side). In other words, try to let your inner artist help you with the same creative energy that helps you paint. Forget any 'shoulds' and 'oughts' and write whatever comes into your mind. Get into a meditative mode, perhaps - by relaxing, sitting with shoulders back and down and feet flat on the ground, and breathing slowly and steadily. But instead of letting random thoughts and feelings drift in and out of your mind, record this stream of consciousness with a pen or on your

computer instead. Don't edit what you write. And don't judge it. Just let it be.

Most important of all is to jot down whatever comes into your mind relatively soon after the creative session you are writing about. Otherwise you could easily forget what was really important at the time. Ideally, aim to write your new log entry the day after a class or other session. If you haven't time, jot down some notes that you can expand later.

HIGHLIGHT IN RED, BLUE AND PURPLE

An idea you may find useful is to read each new instalment of your log and then highlight passages pertaining to practical techniques, emotional issues or philosophical insights. Highlight passages about practical techniques in, say, red; passages concerning emotional issues in, say, blue; and passages containing philosophical insights in, say, purple. If you hand-write your log, either use highlighter pens of different colours, or underline in

***Irish Naval Ship off Whiddy Island**, 2007*

This portfolio page simply shows two photos – one of the naval vessel, the other of an ink painting of the vessel. I painted it with the source photo upside-down so I wasn't distracted by the complexity of the engineering details, but just copied what I saw

Portfolio page, photo

different colours. If you write your log on a computer, colour passages by changing the colour of the font (with a pc, select the text in question, then click on Format – Font – Font colour, and choose the colour). There could, of course, be other topics or themes you'd like to highlight, to help you gain insight as you work with your inner artist.

Highlighting helps you recall useful nuggets of experience and learning at a later date, without having to plough all through each log entry. Obviously it's good to highlight any practical techniques you've learnt. But emphasizing emotional issues and philosophical insights can help move you on in other ways. This is because such areas cast light on the input contributed by your inner artist during each session and during your writing-up of the session. This helps you become more insightful, and also encourages the blossoming of ideas and the formation of new connections.

You may be surprised to find that when you highlight your entries you need each of the three colours virtually every time.

ADD AN 'IN RETROSPECT' SECTION

Keeping your log safe and revisiting it some years later can yield valuable extra rewards. Simply read each entry then comment at the end – under a new heading, 'In retrospect' – which practical techniques, emotional issues and philosophical insights have proved, over the years, to be most useful or even transformative. This commentary will 'crystallize' what you've gained from each class or painting session. This crystallization not only helps the nuggets of knowledge and awareness to shine out ... but also underlines the fact that they are truly yours. This 'concretizing' of insights and lessons learned is, in effect, an affirmation of the input from your inner artist.

YOUR NEW 'BABY'?

Your personal art log is not just a journal, though, it's an important creation in its own right, because over the months and years it, along with your paintings, will add up to a unique and sizeable body of work. As with any new creation, writing your log may impact upon you in one or more ways. You may:

- Be astonished by the visual impact and progression of your portfolio of paintings and log entries – not to mention the emotional and intellectual impact of the passages you have highlighted

- Develop an intense, fascinated and protective bond with your log

- Relate to your log almost as if it were a newborn baby ... familiar yet strange ... known yet unknown ... born of you ... and full of potential

- Feel that this work is very intimate, personal and recognizable as your own, but at the same time acknowledge it is so new to you that it must have been done by someone else. This someone else is, of course, your inner artist

- Discover that your log charts your progress and development as an artist in particular and as a person in general, especially if you keep adding to it for a long time.

What's for sure is that your log will nourish your inner artist in ways that are bound to enrich your creative output.

The last chapter of the book is part of the log I kept while attending several years of weekly art classes.

Chapter Seven – The Author's Log

Here, warts and all, is part of the art log I kept over several years' attendance at weekly art classes in West Cork in Ireland. I usually wrote up my log entry within a day or two of each class. Sometimes I used the present tense, more often the past, but I've left the tenses – and the rest of the text – largely unedited, so that it feels as immediate as possible.

I've changed the names of most of my fellow students.

When writing my logs, I highlighted text concerning practical techniques in red, personal emotional issues in blue and philosophical insights in purple.

The 'In retrospect' section after each class was written very recently and aims to crystallize what, looking back, was especially useful about the lessons. Some insights were apparent from the start, while others have come to me only in the fullness of time.

ART CLASS – year 1, week 1

Lipstick and fork – charcoal sketch

Luckily fear and trepidation aren't normally my bag, so why did I cop out of signing up for adult-ed art last September, and nearly persuade myself not to bother this time? Perhaps it was the scary notion that I might not make friends. Maybe it was anxiety that I might not make some presumed grade – that everyone else would be better at capturing the glorious melancholy of south-west Cork, or more 'painterly' and able to produce more than a good copy of a subject. Or possibly I simply felt like shit both times. Driving to my first class I couldn't help thinking that the students I had yet to meet would be surprised if they knew of the maelstrom in my mind.

Thus unprepared, I parked and went through narrow swing doors into the Arts Centre, past the gallery and office and on through two more sets of doors into a courtyard. More doubt. No one else was here. Was this right? A notice said 'No toilet', so what would I do if I wanted to 'go'? Pushing open another door I entered a room with a barre and a mirror wall one end, a paint-encrusted sink one side, four trestle tables in a square, and several people. A tall bearded twinkle-eyed man greeted me. He was the teacher, John Simpson; I already knew and admired his work as a professional artist. I made myself coffee as invited, choosing the least paint-

Lipstick and Fork – 'Mouth', 2005
charcoal on paper
60x42cm (23½x16½in)

streaked mug, and then sat down. Shyly I introduced myself to my neighbour, Sinead. We then had to fill in a participant details form and I found myself omitting my age. I thought I had no problem with growing older. But Sinead was in her early 30s. And part of me didn't want her to know how much older I was. Once all 13 students had arrived, including two men in their 30s (one, a lovely soul I already knew), the rest women from their 20s to 60s – we gave our names and where we were from. We also said what art we'd done. I blurted, 'Nothing since school'. A lie, I don't know why, because I have done some. Perhaps fear again. Perhaps something less acceptable, like wanting my first attempts to look better than they otherwise might. Forget learning about art – I learnt about myself that evening!

Quite a few students had done a year already, so to get some idea of what might be beneficial to the rest of us, John told us to pick something from our pocket or bag and draw it in pencil or charcoal on an A2 sheet of white paper. I opened a lipstick case, propelled the lipstick up, and spent some moments positioning the two parts of the case by a small wooden fork that I'd saved from a visit to the café at the Lost Gardens of Heligan in Cornwall because I admired their wooden utensils as being much more eco-friendly than plastic ones.

Two hours flashed by, with John circling the room and stopping every so often. My clumsy charcoal stick proved capable of defining thinnish lines and doing subtle shading. The top of my lipstick looked wrong with a dark outline because the light on it made it lighter than its background, but John said I could suggest the darker background with finger-smudged charcoal, so the lipstick looked pale against it. It worked. Hesitantly, I used the same technique to fill in the faint shadows of the three objects. And that tied them together.

John signed off, saying he wanted us to keep a sketchpad and do some drawing every day for him to see next week. Amid the collective gasp, 'But I haven't time!' I was struck by what a joy it would be to draw every day.

As I packed up, I realized the oral connotations of the lipstick and fork I'd drawn, so I entitled my picture, 'Mouth'. I also thought that my initial anxiety might not weigh as heavily next week.

In retrospect:

What a fascinating and wise move it was to get us to make a piece of work out of something as trivial as bits and pieces we happened to have on us at the time. The absence of preciousness *à propos* choosing a subject was an important lesson. Our inner artist doesn't care where our source material comes from. I had imagined I'd have to choose carefully what to paint or draw. I now realize that using what you have, or what your environment provides, is part of what makes being an artist challenging and revealing. None of us could have controlled what we had on us that night yet the serendipity of those found objects was as perfect a starting point as anything more contrived could have been. The sheer haphazardness of the objects and the resulting power to create something personal was a good lesson.

How valuable, too, to create a composition, not to mention something of meaning, from such simple, day-to-day objects that could by no stretch of the imagination be called 'arty'.

far left: ***Cardboard Sculpture –
sketch,** 2005*

*charcoal on paper,
60x42cm (23½x16½in)*

left: ***Cardboard Sculpture – quick
sketch 'Spiral Burst',** 2005*

*charcoal on paper
60x42cm (23½x16½in)*

ART CLASS – year 1, week 2

Cardboard sculpture – model; pencil sketch; quick charcoal sketch

En route to my second art class, I again felt unexpectedly anxious. This time it was because John wanted us to make a model then draw it. But all I wanted to do was paint. I didn't want to model anything! I won't go, I thought. Why should I, anyway? The thrill of being an art student for two hours a week evaporated and I felt fed up and frustrated. The raw, selfish emotion belonged to my two-year-old self, as did the realization that I could say 'no'. I couldn't see this then, though.

In I went. And while it was good to greet Sinead, the 'girl' who sat next to me, and disappointing to learn that Jack, the 'boy' my other side the previous week, wasn't there (I was still in child mode, albeit now five years old), I then saw a pile of rough corrugated cardboard sheets, and heard we were to tear up a sheet, make a short tear in one side of each piece, and construct a model with the pieces. Nothing in particular, just a structure whose surfaces would catch the light in different ways. We were then to draw it in pencil, and

use lighter and darker shading to make the image appear three-dimensional. It sounded remarkably difficult and my heart sank. But I started tearing ... and the magic began.

I cut a spiral from my cardboard, then used long strips to stand the spiral up. This was fun – exciting even – and after 20 minutes of pure concentration I had a towering creation with the spiral amongst its props having a certain sinuous beauty. All too soon John wanted us to move on from modelling to drawing, but I added one last piece – a doubled-over strip whose corrugations enabled me to make a star in the centre. I mounted it on top of my model.

And there – I was really pleased. I turned it round and round, put it on its side and admired it. Then I drew it with fierce concentration and undiluted pleasure. The making of the long curved lines of the parts of the spiral that show, didn't just seem to come from my hand and eye. A more primitive force from inside me – between my tummy button and the bottom of my breastbone - seemed to fuel the movement of my pencil. I loved the feeling. The complexity of the structure seemed as nothing because I was looking at its parts, not yet its whole. I was looking at light and darkness, at spaces beyond, between and around, at shapes and angles and directions. And all was well.

Afterwards, we circled the tables in awed silence, witnessing the extraordinary fruits of our labours. There was no right or wrong. Each model just 'was'. And not only was that extraordinarily liberating, but I was bowled over by our communal welling up of creativity.

In retrospect:

In only the second class I was challenged to think about shape, form and light and to represent a three-dimensional object in two dimensions. And all in two hours!

The big lesson was about what artists do as they transpose real life into two dimensions while fooling the viewer into believing there are three.

Also, no one told me to make that complex cardboard spiral – *I* let myself choose to create that particular construction ... and both choosing and doing it were empowering and rewarding. My inner artist accompanied me all the way, and since that day the feeling of fire in my belly when doing anything creative has become commonplace.

ART CLASS – year 1, week 3

Clay model; 3-colour gouache painting

Here we go again, but this time with me looking forward to art class for the first time, and John giving each of us a handful of bluish-grey clay. The plan is to handle this clay so as to feel its substance and weight, then to make something and paint a picture of it. John wants us to get a feeling for the clay's substance, solidity and mass, and represent it on paper.

But it's almost back to square one for me. I've never worked with clay. There's no kiln, no glazes, so the thing I make won't last. Any number of no-nos flash through my mind, plus that familiar heels-in-the-ground feeling that 'I won't do it!'. But the toddler in me recedes when I actually handle the clay.

I want to make it into something other than a solid sphere – I want it to be light and long and mystical and never-ending. I roll it with my hands into a long spill like the shape of my Danish rolling pin, then continue rolling and elongating it until I think it will crack if I tease any more length out of it. I flatten the spill, neaten its ends, and give it sides. Then I pick up one end, twist it, and join the ends together. The clay now has form and life. It's a sinuous figure-of-eight 'Moebius strip' with no beginning and no end. It's exciting, with swoops and glides and hills and mountains. Like a roller-coaster where you spin round and round and upside-down. And with dark mysterious places … caves …

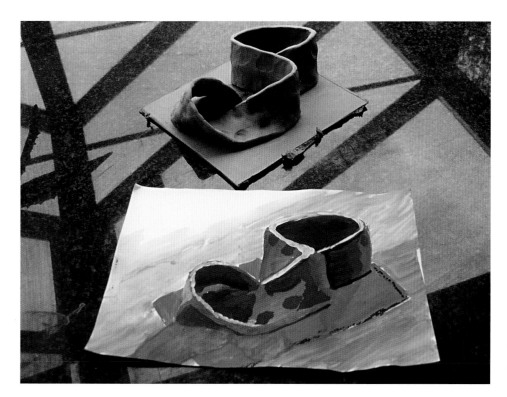

Never-ending Loop, 2005

Photo of the clay model and the painting of the clay model

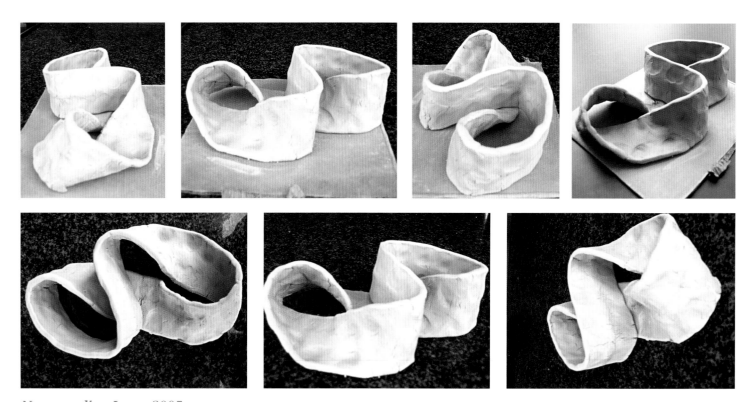

Never-ending Loop, 2005

photos of clay model

where you can't see through. I fall for my creation, smooth it, stroke it, curve it more, and turn it round and round, modelling it into the form I like best. John suggests putting it on a piece of corrugated cardboard to make it easier to turn. This works well.

Now comes the paint. PAINT! So far, in the first two classes, we've used charcoal and pencil. Now there are three great plastic bottles, like giant squeezy ketchup bottles, of yellow ochre, black and white paint. It's gouache. I ask John what this is and he says it's like poster paint. That's what we used at school, and I never painted anything I liked with it. But

perhaps painting a picture of the clay model will be different, because I like the model.

Representing the clay model on paper feels almost as if I'm anointing the model itself, letting the paint flow along its curves, fly over its summits, outline its sharp edges, darken its deep recesses.

Too soon the class is over.

We look at each other's work in amazement. There are other models, not just our own. Other babies. Other dreams. And each of us is the painter of our own creation.

ART CLASS – year 1, week 4

Apple, orange, soda bread, eggs, egg box – 6-colour gouache painting

I arrive bright-eyed and bushy-tailed, encouraged by the pleasure I'd had from making a cardboard sculpture and doing a pencil sketch of it in week 2, and making a clay model and painting a picture of it in week 3. Then I see what we're to do. Between each pair of places around the trestle tables, there's what's obviously to be the subject of a still-life painting. It's heartsink time. Again! The arrangements look unimaginably difficult to represent

In retrospect:

Most of us when producing a two-dimensional image of a 3-D object benefit from looking at the object or at least remembering it has three dimensions. But neither is the same as getting our hands around it so we can sense it and caress it. Handling, feeling and shaping the clay were important as a metaphor and a guide, especially to those like me who learn particularly well from kinaesthetic input – touch, and the movement and position of our body.

How important then to remember when representing something in one plane that we can allow our kinaesthetic memory and imagination guide our work. Our creative energy thrives on inputs from every part of our mind and body.

Apple and Eggs, 2005
gouache on paper
19x28cm (7½x11in)

In retrospect:

Painting what I actually saw instead of what I thought I ought to see quickly conquered my fear of what I'd thought would be impossible. But the even bigger thrills of the evening were my physical involvement in painting and the feeling that my brush was dancing – and these have been repeated many, many times since.

on paper. For one thing, each one is resting on a scrumpled sheet of brown paper. For another, the objects are an orange, an apple, a chunk of soda bread, two eggs and an empty cornflower blue egg-box. How on earth does a week-3 ad-ed student depict an egg-box?

This week we're allowed six colours of gouache – yellow, red, blue, white, black and green. But then John drops a bombshell. We're to paint with our fingers or with a folded piece of paper, because one of the other teachers has taken all the brushes on a field trip. I glower inwardly. I always knew art was too difficult.

I deflect my feelings by collecting two glass drawing boards for my neighbour Jack and me to rest our paper on, and two paint trays. Jack offers me a brush from a set he had for his birthday, and I choose one with relief (though part of me would have liked the messiness and challenge of folded-paper 'brushes'). The subject is almost overwhelmingly daunting but, as John suggests, I start with a pencil sketch. Then I begin painting, choosing to start with the apple as it looks nice and round and comforting, and easier than everything else. I mix a green, and once my brush starts swirling round the apple's curves, I'm away – the painting of the curves seems more than the physical movement of the

brush, it's as if my whole body is creating this amazingly beautiful arc ... as if the whole of my 'I' is in the brush and willing its paint to represent the apple.

I remember John's teaching in week 2 about getting a 3-D effect with light and shade, so I add dark brown to the apple's under-surface, and white-with-a-hint-of-green to its upper side. I portray a bruised indent on the fruit with the same technique. Then I paint in the stalk and a real apple emerges on the paper. This is good fun, and my brush is almost dancing. Even the eggs are enjoyable now, though I struggle with the bread, and the egg-box seems impossible.

But I try to paint what I actually see, rather than what I think I should see, and I concentrate particularly on the dark depths of the hollows in the egg-box. The box finally comes to life with the last few strokes of highlight, done with white-with-a-hint-of-blue. I try to earth the objects with shading on the crumpled paper. **But then it's time to stop.**

I feel absolutely shattered. Physically exhausted. This hasn't just been an exercise in confidence-building and hand-eye co-ordination. It's been a whole-body work-out.

ART CLASS – year 1, week 5

Wrapped object – acrylic painting

With family staying, I go to a performance of King Lear rather than art class. But I know what the others are doing, because John told us last week that we were to choose a household object, wrap it up in something, and paint it.

So, later in the week, I ask my daughter if she'd like to paint with me at the kitchen table. We use acrylic paints that had been my father's, and she paints flowers while I pick a little white Danish wooden horse from the dresser. It's decorated with tiny blue and

Wrapped Horse, 2005
acrylic and pencil on paper
19x28cm (7½x11in)

turquoise flowers, and I'm reluctant to hide its chunkiness and pert prettiness, so I wrap it in a clear polythene sandwich bag. Clever clogs, I think.

But it's more of a challenge than I realized, and without John I don't know where to start. Hesitatingly, I use a 3B pencil to draw the horse and the outline of the polythene plus a few of its creases. I then start to paint the horse. I find it difficult to show the slight differences in shading, and I battle to do so with white-with-a-hint-of-yellow and white-with-a-hint-of-grey.

My son comments that a polythene bag isn't the easiest of wrappings to draw. But I look again and now I can see shiny white lines where it's folded over and slightly shaded bits where the transparent plastic isn't catching the light. So I put them in.

This works after a fashion, but I'm none too keen on my horse in a bag – and suddenly I realize it isn't earthed. It doesn't seem to be standing on anything. I remember John saying we need to show what's

around an object, even if we show only a little of this, because everything exists in relation to something else. (Art sometimes seems as much about philosophy or psychology as about technique.) So I start to ground the horse with dark shading, and realize I should show this shading under the polythene, too, because the polythene isn't hiding anything as it's there but almost not there. It would have been easier to put the shading in first, then paint in the crease lines on top,

rather than try and paint the shading in around the crease lines. It seems too hard to do.

But it's only as I tentatively fill in some dark shading that I connect with my painting. These very bits that I least want to do are the ones that draw me in and make me feel part of my creation. Maybe there's an important life lesson in this, for I love my little horse-in-a-bag now it has some shade, even if it does still look a bit as if it's floating in the ether.

In retrospect:

Trust me to choose to wrap my household object in something see-through when we'd simply been asked to wrap it up! Depicting it seemed impossible at first and I wondered why I'd taken it on. But feeling my way around that inner space within the transparent covering turned out to be rewarding. That day I

learnt to trust my choice and summon the courage to follow it through. What a challenge to land on myself, yet what a magical result.

It was also the first time I realized the importance of giving an object a base or a floor to rest on.

opposite page (left to right): *Bottles etc – 'Tones' – contour sketch*, 2005

pencil on paper, 24x30cm (9½x11¾ in)

Bottles etc – 'Tones', 2005, *charcoal on paper, 42x60cm (16½x23½in)*

Bottles etc – 'Tones' – quick sketch, 2005

charcoal on paper, 42x60cm (16½x23½in)

ART CLASS – year 1, week 6

Tones – pencil contour drawing;
charcoal sketch, quick charcoal
sketch

The weather was too bad for John to
come over from the island where he
lives. So a friend of his, Barry,
another professional artist, took
over. He was very keen to tell us
things about how to draw, and
bubbled over with what he had to
impart. There were only four of us
(Caroline, Emer, Jack, me) because of
the terrible weather.

Barry arranged a still life of a large
white plastic container, bottles and a
tin on the table. First we had to do a
contour drawing – not looking at the
paper but just outlining the
composition. It was to encourage us
to look and to draw what we saw,
without reference to the image we
produced. I was fine with that.

Then we had to draw it in charcoal,
concentrating on the differences in
tones, particularly at the junctions of
objects, and objects with back-
grounds. This was really useful for
me, and for the first time I could see
how to define a lighter object against
a darker background not with a line,
but by shading in the adjacent
object. I found the charcoal some-
what unwieldy, though, and didn't
much like my picture. We did a
second, faster one.

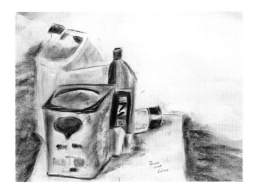

What was good was using the side of
the charcoal, and getting really black
hands! And I liked Barry's
enthusiasm and his belief that he
had techniques to teach us that
would help. I'd never really seen
drawing as having techniques as
such. I thought you were either good
at it or not. But now I'd like to learn
more techniques.

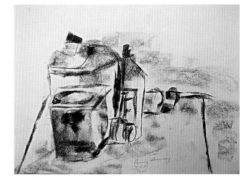

In retrospect:

I think the learning of drawing
and painting techniques is often
oversold, since it's possible to
make fascinating and highly
creative marks without ever
having being schooled. However,
this class demonstrated that a
certain amount of technical
know-how is well worth having.
Learning to look carefully then
draw what we saw has proved its
long-term value. Everyone has an
image bank of what they think
objects look like, but artists need
to put their preconceived ideas
to one side so they can look
deeply at their chosen subject
and recognise what makes it
unique. This skill is worth
striving for so we paint what we
actually see, rather than what we
think we ought to see.

Practising such skills rather than
just reading about them in
books makes them relevant and
interesting.

ART CLASS – year 1, week 7

Poppies – 5-colour painting of fragments from other work

During the previous class – which I missed – they'd talked about emotions and art and looked at art books, but hadn't painted. This week, one fellow student, Emer, said the class had disturbed her and left

her angry. She said poppies made her angry. I'm not sure what prompted the link, but it had recently been Poppy Day in the UK. I remembered that the paper poppy I'd bought over there was sitting on my kitchen worktop. Someone – I think me – said that poppies symbolise the blood spilt on the fields in World Wars I and II. This led Emer to talk about Ireland being a neutral country, and also, I think, about English soldiers killing a friend or relative of hers during The Troubles.

As I listened to her anger I felt shell-shocked and guilty. Defensively, I talked about how the British helped protect Europe against German invasion. How my husband's Polish grandfather had been rounded up – along with other members of a local businessmen's club – in his home town of Ostrow in the county of Poznan by the Nazis, made to dig his own grave, and shot. And how his 16-year-old Polish uncle had been evacuated by train from Poland towards the safety of the east, only to be killed when the train was strafed by German planes.

John, and Chris – the only other student that evening, were English, and although nothing personal was said, there was an air of attack ... the atmosphere seemed dangerous. There was a moment of silence.

John said he'd like us to paint a wash of colour over the whole of a piece of paper, then select bits of the art-works we'd done, and piece them together as a picture, using black, white, red, blue and yellow paints to put the images directly on the paper.

I washed my paper with grey. Then I chose the lipstick from the lipstick and fork picture of the first class, and put it with the cave-like hollow part of the picture of the clay model from the third class.

As I brushed in the images, the painting took on a life of its own. The lipstick became the red-tipped nozzle of a sleek, shiny, potent gun, the part of the clay model its body and handle. Then the first part of the gun's nozzle developed into a bird – a dove of peace, perhaps. The handle of the gun became entwined with a poppy with a green stem (symbolic to me of blood

top left: *Poppy Pistol – initial sketch*, 2005
pencil on paper, 20x30cm (8x12in)

left : *Poppy Pistol*, 2005
gouache on paper, 19x28cm (7½x11in)

and death, but also of peace, hope and growth). And the body of the gun became decorated with a pale blue symbol - it looks to me now like a divining rod but, at the time, its shape seemed like something you might find on a cowboy's gun. Finally, the background to the gun's nozzle and handle became suffused with pale pink.

I wanted to discuss my picture with Emer, but didn't have the time ... or the guts.

In retrospect:

The enduring lesson has been to awaken awareness of the possibility of reusing part of a work to create something new. Every bit of a particular painting says something about us and how we felt at the time. But this isn't the only way in which it *could* express meaning. It's all about context. After the e m o t i o n a l l y - c h a r g e d conversation with my class-mate, my unconscious used my lipstick as a very different symbol.

One of the amazing things about being an artist is that no one image has a single meaning. Depending on how it's used, it can take on a completely different emotional tone.

ART CLASS – year 1, week 8

Acrobats – pastel copy of a photo

This week we're to do whatever we like, and I've brought in an astonishing photo of two circus acrobats cut from an in-flight magazine. It's astonishing partly because I've never seen two people in this pose (one on his back with his legs up in the air and splayed very wide apart; the other standing on the first one's soles), and partly because

Circus Acrobats, 2005
pastel on paper
21x30cm (8¼x11¾in)

of the dramatic colours – a black background with reds, oranges and pinks in the skin of the spot-lit figures, and deep pinks and purple on the trampoline. Something drew me strongly to this picture – perhaps its drama, perhaps knowing what skill, strength and concentration must have been involved in holding the pose, but most of all its symmetry and the extraordinary shapes formed by the men's limbs and torsos.

I used black paper plus pastel crayons, and worked anti-clockwise around the two bodies. The stances and lighting were so unusual that it was easy to draw what I actually saw, rather than what I thought two men in that position should look like. Just as in previous classes, I felt intensely involved with the picture from the moment I started, and surprised by how fast the time flew.

Back home I found myself drawn to look at the picture again and again, fascinated most by the strange shapes and their energy, vigour – even danger.

In retrospect:

This class taught me about trusting my eye to find a stunning image. Once you become an artist you'll find yourself noticing all sorts of wonderful, challenging or otherwise exciting images ... or simply images that speak to you personally. You can keep these to hand by storing tear-sheets, photographing images, or feeding them into your inner database ready to call on some time in the future.

When we do a figurative painting (one that's representational as opposed to abstract), our unconscious may scan the database and use a stored image to modify the work in hand. Sometimes our re-collection of images and symbols even appears to come not from our personal past but from humanity's collective unconscious. Research shows that many disparate peoples in the world have certain commonly-held images and symbols that have never knowingly been shared.

ART CLASS – year 1, week 9

Gauguin's 'Tropical Paradise' – gouache painting

The piles of art books were out again, and John suggested we look to see whose work we liked, and to choose a painting to copy. I chose Gauguin's 'Tropical Paradise'. I loved its riot of colour, and thought that the peep of sea and Japanese-style (pointed-top) mountains above the trees looked like a view I'd seen in Glengarriff that day.

My concern was how on earth I'd have the time or ability to copy it. It seemed impossible, but once I started, the copying took on its own energy and pace, and to my surprise I found myself enjoying it hugely.

What did I learn from this class? I took away a deep admiration for the way the artist had composed his picture. There was something very special about the way the slim trunks of the two tall trees were angled to the left, and the way the pink path sloped away from the trees. The interaction of these two opposing directions gives the picture a sense of looming disruption that overlays the beauty of the scene. It's as if a tiger might appear any minute, or the mountain might spew out fire and lava

left: **After Gauguin's 'Tropical Paradise'**, *2005*

gouache on paper
49x29.5cm (16½x11¾in)

above: **Gauguin's 'Tropical Paradise'**

photo

I also learnt something about creating different effects by using particular brush strokes – little dots for pebbles, little straight parallel lines for grass or twigs, and small blobs of white on a green bush for very passable flowers. I tend to be careful and pernickety – perhaps thinking I must be a good girl and make things look right - but Gauguin was able, with much looser painting, to create an impression that, while just as vivid and beautiful as a photo, was more magnetically attractive and more strangely disturbing.

At home next day, I photographed my work, put it on computer, and produced a small-scale copy in a greetings card format. I also put my acrobats picture from the previous class on a card. I love them both.

In retrospect:

This lesson about learning from the Masters and becoming aware of how particular techniques and skills result in such different results was most valuable. However humble we feel as novice artists, there's no shame in standing on the shoulders of giants to get a better view of the horizon.

ART CLASS – year 1, week 10

Easels in mirror – charcoal sketch

Our return to art class followed a 10 week mid-winter break, and it was with some trepidation that I pushed open the heavy pair of swing doors into the hall, exited via a similar pair the other side, traversed the starlit courtyard and entered our spacious studio. John and Chris greeted me, Sinead, Emer and Jack followed me in, and two new students, Clare and Brenda, arrived. The easels were up and John suggested we tape a glass board on our easel so it didn't fall off. I was all fingers and thumbs while threading the tape behind the easel. As soon as I'd done it I wished I'd put the board lower so I could sit down, but there weren't any lower holes in my easel for the pegs that supported my board, so I decided to stand, like everyone else.

Coffees made and chatting done, we wait expectantly for our subject for the evening. Then the bombshell. We're to use charcoal to sketch a view looking towards the mirrored end of the room. The snag is that the room is full of easels, boards and rounded black plastic stackable chairs, not to mention students. It's a chaotic scene that looks far too complicated to draw. And the mirror doubles the chaos. It's groan-time again. It's impossible! I don't want to do it. I feel like stamping my feet.

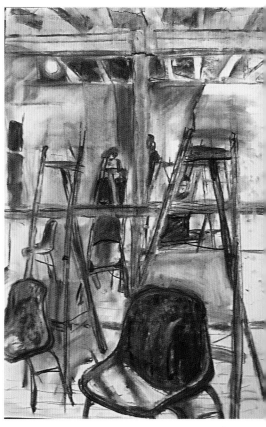

Easels in Mirror, 2006
charcoal on paper
60x42cm (23½ x 16½in)

I postpone the agony of starting by arranging and rearranging my easel several times. Then there's nothing for it but to make a mark. And off I go, intense concentration shutting out the can'ts!, won'ts! and shan'ts! in my head. The objective, I dimly hear John say, is to get the spacing right between the real and reflected objects.

I map out the chair closest to me and an empty easel behind, then draw in the ballet barre that's in front of the mirror. Carefully I draw in another empty easel and chair, then I sketch the backs of two easels plus the heads and legs of their users – all reflected in the mirror. Then I realize the spaces between the four easels aren't right. John says it's best to redraw them where they should be. We can put right our mistakes, he says. We don't have to live with them. What? I think ... but I've just spent ages doing these easels. At his suggestion, I smudge out the second one I did, which is the problem one. Then I redraw it. And suddenly the spaces work. And not just that, but suddenly I feel powerful. I can make changes. I'm not stuck with a lash-up. I can put things right. It's a good feeling.

I add floorboards, the top and bottom of the mirror, a vertical beam, and some exposed rafters plus their reflections in the mirror. I go deep into shaded corners and crevices to highlight lighter surfaces by their side. And using my charcoal I caress the rounded contours of the chairs I've depicted. The nearest one looks so solid and comfy I could almost sit in it. That would be good, as standing and concentrating so hard for two hours has been exhausting.

I take my drawing home, pleased I've made some order out of chaos. And most pleased that getting things wrong doesn't matter because I can put them right. An important lesson for life!

ART CLASS – year 1, week 11

Fruit and veg on white paper – pencil sketch

Not so many of us this week – perhaps because last week was so daunting. John has slightly scrumpled a large piece of white paper for each of us, put it on the floor by an easel, and arranged on it an apple on a white paper picnic plate, another apple and an orange by the plate, and a couple of onions and a tomato a bit further away. Not very prepossessing, I think. We're to sketch this in pencil on white paper on a board on an easel.

I choose an easel with low enough peg-holes so I can sit comfortably, as my week has been extremely busy, and I don't fancy standing.

I spend some time choosing a view of my still-life tableau, and get going. Like last week, we're to think about placing things relative to each other,

In retrospect:

Few things present such a threat to a novice artist as a mirror. The challenge and fascination of a mirror is that we see not only the front but also the back of each object. This never happens in real life. Many artists look at their work in a mirror to detect nuances they'd previously been unable to perceive. In a mirror the image is reversed and the potent resulting unfamiliarity makes us see the work - and what more needs doing - afresh. In psychological terms we are all, in any one moment, both a subject and an object, and working with a mirror helps to reveal this dichotomy.

The other important lesson of this class was that a mistake need not be a lasting problem - all you need do is spot it and correct it.

focusing on the spaces between and, when they touch each other, the edges between them. My favourite things are the shadowy depths, plus the shady sides of the various mountains and ridges in the scrumpled paper. I also like the dark bit in the dimple at the top of each apple, though I realize somewhat tardily that two of the fruits aren't apples, but onions. Maybe I should wear my specs!

John suggests using parallel unidirectional lines to depict the shading on the paper mountains, and this immediately makes the drawing look more artistic. I feel that were I the size of a mouse - or one of the borrowers in Mary Norton's children's books - I could slide down the slopes into the valleys. That would be fun. Another thing I like is the strange arrowhead-like shape of the piece of paper. And I like putting little slanting parallel lines around the very edge of the paper plate. At first glance I didn't dream I'd ever be fond of this unpromising subject. But I am.

ART CLASS – year 1, week 12

Fruit and veg on white paper – 3-colour gouache painting

I'm sad tonight because Sinead – who I sat next to in our first class – told me in town that she wasn't coming any more. She has young children and looked tired. She left the last class early, and I wondered whether she didn't like it, or whether there was pressure on her not to be away from home too long. We're a small class – just Clare, Jack and me. John points to arrangements of fruit and onions on scrumpled white paper. This time they're set on tables, not the floor, and there are no paper plates. We're to use easels again. This is only the fifth time I've used an easel – four times here, once

In retrospect:

Although I joked with myself about mixing up onions with apples, there was a lesson here. Our culturally-conditioned inner eye sees what it will. Perhaps one reason why the surrealists were so special was because the windows they gave us on images were beyond our own accepted, sanitised and filtered ones. Who's to say that the apple and onion weren't related (and thus confused) in my mind that day? That it had nothing to do with my eyesight - more my in-sight. We often mistake one image for another in life. Look at the research into witness statements of those shown the same scenes under laboratory conditions. People swear on oath that that they saw things they could never actually have seen.

This is all grist to the mill of the inner artist, who knows that we see our own images of every-thing. In this sense we can never really trust what we think we see. The Mayans had a saying, 'All life is an illusion'. Being an artist is about tapping into your own unique perception of that illusion.

In retrospect:

The experience reminded me of a Cordon Bleu cookery course I did many years ago. My fellow students were mostly pro-essional chefs. Imagine my shock when the teacher announced that one of the most important things to learn was how to recover a dish that had gone wrong. He said that any good cook can make a great meal but few can salvage a disaster and come out triumphant with an appetising meal for demanding and hungry customers. It's the same with painting. No one cares whether we ran out of a colour or had some other methodological disaster while painting. They care only about the result. The skilful artist uses their experience and resourcefulness to make good where others give up.

The feeling that my brush is dancing with me on the paper has happened again and again over the years, and is part of what makes me love painting.

left: *Fruit and Onion, 2006*
3-colour gouache on paper
60x42cm (23½x16½in)

below: *Fruit and Vegetables, 2006*
pencil on paper
42x60cm (16½x23½in)

at my sister's, and I'm almost blasé about it now. Easels and other art hardware seem to me to get in the way of drawing and painting at first, until they become more familiar.

The aim again is to depict relationships between the objects, paying special attention to junctions, shade and light. But instead of pencil, we're to use just three colours of gouache – yellow ochre, black and white. Not very encouraging colours, given the green apple, orange orange, and brown onions.

Painting the shading of the mountains and valleys of the scrumpled paper is quite different

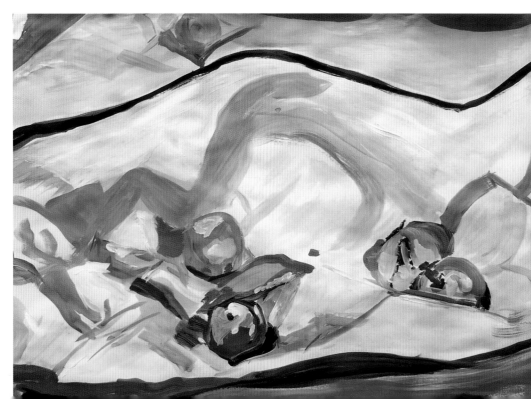

top: *Kettle and Radio – 4 tones,*
2006

pencil on paper, 42x60cm (16½x23½in)

above: *Kettle and Radio – zen*
scribble, 2006

pencil on paper, 42x60cm (23½x16½in)

from shading them with parallel pencil lines, as we did last week. I use a large brush and feel much freer than before, when I've used a smaller brush. I also notice I'm not scared, as I've often been in class before, especially with paint. Instead, I'm enjoying my brush, and it and I are dancing over the paper. John suggests I fill in some detail of what's surrounding the scrumpled paper. There's a mirror behind my tableau, but no matter – if you can draw easels, chairs and people in a mirror, like we did the week before last, anything else seems a doddle! The colours made by mixing my three permitted paints fascinate me. Who'd have thought you could get green from yellow ochre and black? And however did I manage to get orange?

It's a good experience … a heart-sing evening. As I get in the car I get paint from my wet picture on the steering wheel, but it's no problem.

ART CLASS – year 1, week 13

Kettle and radio – 4-tone pencil sketch; scribble sketch

This evening I'm greeted by Barry, the professional graphic artist who stands in when John is away. Chris is there too. Then Jack and Brenda join us for what turns out to be, in part, a zen evening. The zen of ad-ed art!

First, we have a Q and A session, because Barry likes us to talk about the process of learning to draw and paint. We then do a pencil sketch of a very shiny tall modern jug kettle, and an equally modern two-tone radio. Very unprepossessing, but the objective is to look, look and look again, and assign every part of what we see to one of four tones, ranging from the darkest shade of a 3B pencil to the white of the paper. This is good fun and I painstakingly produce a good-girl copy of what's in front of me. But somehow – although I've enjoyed outlining the dark, medium, light and white reflections in the kettle, and certainly it's accurate enough – the drawing does nothing for me. It's tight as a button!

There's no coffee tonight because Barry didn't realize that John personally organises a jar of instant, plus milk, a teaspoon and clean mugs, each week. Hmmmph! Energy and morale sag as he talks about drawing again.

Now he's talking about looking, looking, looking again, and telling us how a good artist looks at the object that's being drawn for 80 per cent of the time, and at the drawing itself for only 20 per cent. My ears prick up. That's interesting, I think.

We're to do another drawing – the same objects, but this time a scribble

drawing. Not a random scribble, but repeated pencil strokes, almost as if we're feeling our way around the outlines and within the tones, albeit at a distance. **This is how I draw when I'm left to my own devices, so I like the sound of it.**

Barry goes into almost manic mode. He walks around and around our three trestle tables, pausing briefly behind each of us as he goes and keeping up a low-pitched, even-toned monologue of 'look, look, keep looking, that's good, that's right, just draw, draw, keep drawing, let yourself go, look, look, look.'

My energy level rises exponentially and my pencil skims and hops and skips and enjoys itself no end. Then the big smile on my face broadens, like when I'm cycling, and I start laughing. A small low laugh, coming from deep inside, and almost uncontrollable. Not hysterical, but relaxed and released. There's an extraordinary feeling of being almost mesmerised or hypnotised as we scribble our images of the kettle and the radio.

'That was a zen experience', I said to Barry afterwards. 'Yes', he said, looking satisfied.

And you know what? My scribble was so much more pleasing than the careful drawing that had taken at least five times as long!

ART CLASS – year 1, week 14

Apple and pear on white-painted board – 8-colour gouache painting

Lots of still-life tableaux greet me, each with an apple and a pear nestling on a small scrumpled piece of brown or purple paper atop a large sheet of scrumpled white paper. This time my enthusiasm doesn't just ebb away – it floods into my shoes. I've seen this white paper before, and I'd swear we've painted these apples several times before. It looks difficult. I don't want to do it. I'm the first here, and I think John senses my disappointment.

He says that this evening we're to paint with six colours: two reds (one bluer than the other), two blues (one sharper than the other), two yellows (one more lemony), plus black and white on a small white-coated plywood board. **This sounds more interesting.** I set up my easel by a golden pear with brown speckles, plus a red apple with a bright green splodge, on brown paper. The apple is a real fairytale jobbie and makes me think I'll like this subject after all – but I forego the purple paper with some regret.

In retrospect:

Most of us believe that the more we try, the better the result. But this class put the lie to this. My tendency is to be a do-er. Over the years, though, I've come to realize that time spent looking rather than thinking or daydreaming is time well spent. Barry's insistence on spending more time looking and less time doing anything with our hands prompted a big move forward for me.

Linked to this was finding that doing something quickly and with little conscious thought was freeing and fun. When I guide newcomers to painting and drawing they often want to start by drawing in detail. They then quickly become dispirited and exhausted. One key to releasing creative energy is to be unself-conscious enough to let it out. This energy is universal but often shut in by our inner critic and various adverse experiences. However, getting a head of steam going, as in this class, can release the energy. More years as an artist have taught me it's common to have a zen exper-ience when painting. I neither invite it nor prepare for it. It just happens. And it's lovely!

Furtively I reposition the pear closer to the apple so there's shade between them. I remember it wasn't that difficult to highlight and shade the scrumpled paper with pencil in one class, black, white and ochre paint in another. Chris, Brenda, Emer and Jack arrive.

I've brought my father's brushes; some lovely flat ones my mother-in-law gave me for Christmas; and a few new ones I've bought. John, as usual, recommends a large brush. It's the opposite of what I'd choose, but I'm learning that a large brush makes paintings look more painterly and covers the area faster.

I try to see the colours in the shadows of the white paper. They look lilac, pink and blue, so I use the sharper red and blue, plus white. The colours are surprising, but right, and the lilac is so lovely that I realize I needn't have regretted not choosing a tableau with purple paper. This is a good lesson for me. There are often lots of colours in things that look boring at first glance.

The bright parts of the white paper have a creamy tone, so I add a smidgeon of yellow to white paint, and tone it down with a tiny bit of brown I've already mixed.

I concentrate on the highlights on the fruits, and the darkness between and beneath the fruits. The more

Apple and Pear, 2006
8-colour gouache, 20.5x20.5cm (8x8in)

accurately I copy the colours in the tableau, the better the painting becomes. But I don't like my apple because it doesn't look like an apple I'd want to eat. John looks long and carefully then suggests a wash of light colour over part of each highlight, so it isn't as white. Now my apple looks real. Each highlight needs only a tiny spot of white – because while each highlight is lighter than the rest of the apple, it's slightly darker than I'd thought.

As I look and look again I see more and more variation in the colours of the apple, and contours appear where I hadn't noticed before. My brush adds brownish-red here, yellow-green there, a shadow around the stalk, more speckles on the pear, and a line of shade around two edges of the brown paper.

That's it. Time's up. I can't believe I've produced something because it seems like I've been doing it for only five minutes – but two hours have evaporated.

We look at each other's paintings and I tell Chris I like his apple then feel awkward in case this sounds suggestive. I also wish I'd used descriptive praise, because I know from my early work with children as a doctor that it's more appealing and meaningful to the creator than judgmental praise (eg, 'that's good', or 'I like that').

In retrospect:

Most of us in Western cultures are somewhat linear in our thinking. We see a task or desired outcome, make an internal map of the journey needed to achieve it and progress step by step towards our goal.

In many areas of life this can work well but it rarely works for the creative individual in any sphere. Our journey as creatives often cannot be known before we start. We may have a general idea of the map and even the destination but we don't how we'll end up getting from A to B.

John's point about losing his subject and finding it again affected me deeply. To continue with the map metaphor, getting lost on a journey doesn't mean we'll *never* arrive at our destination. We may have to go via a different route, and we may have unexpected adventures along the way, but the chances are we'll still get there.

It's the same with painting. If we focus entirely on the product and fret when we think we've lost sight of it, we'll be unable to make the best of and to enjoy the process. More important still, we'll have shut ourselves out from the opportunity to create something new.

There's a lovely Irish story about an English guy who, on finding himself lost in a country lane, asks a farmer if he can tell him the way. 'To be sure', comes the reply, 'but if I were going there, I wouldn't be starting from here'. Here's a lesson for our life as an artist. We may have to re-start our journey many times, and from places we'd never have imagined. What a privilege.

We all look at John's own painting, and he makes a riveting comment. As he paints, he says, he often loses his subject, then later finds it again. And this can happen several times. But, he tells us, it doesn't matter – you just keep looking, paint what you see, and move anything if you realize it's in the wrong place.

This is a lesson for life. I didn't dream I'd learn philosophy or psychology at art class. But each class seems to teach me something new that enriches my soul.

ART CLASS – year 1, week 15

Fruit and tissue on white paper – 8-colour gouache painting

A notice on a chair outside the classroom says John is upstairs watching TV. He's on a Nationwide interview as one of two artists living and working on Sherkin Island, off the coast of south-west Ireland. I missed last week's class when he told everyone he'd be on tonight. No sooner do I see the notice but he appears, slightly flushed, and explains. Some minutes later the others arrive. Everyone is excited. I feel proud of him, and pleased my teacher is on TV. Someone promised to video it, so hopefully I'll be able to see it, too.

Tonight the trestle tables are strewn yet again with fruit on crumpled white paper, but this time with torn pieces of lime and turquoise tissue. This is a colour combination I love; in fact I find it heart-stoppingly wonderful – so my spirits lift. I spend a minute or two walking round and choosing which collection of oranges, pears and apples, and especially which section of coloured tissue, I want to paint. The section I choose is a swooping curve of lime and turquoise tissue, with little squiggly lengths of lime tissue coming off it. Most of all I love the curve of this shape. But I also like the way the fruit emphasizes the curve by seeming to tumble down it. This curve (like, I realize, other curves and swoops and exponential arcs I've drawn) has a visceral effect on me – by which I mean I feel that I, like the fruit, am tumbling down and around that lime and turquoise curve. And that's exhilarating.

My painting seems freer today, perhaps because I've learnt I can make shapes, I can paint shadows and highlights, and I can mark the paper to show its creases. I like placing the fruits and tissues on the paper, and I particularly enjoy painting the swooping curve of the tissues.

The main challenge is my use of paint. The lime isn't right, partly because there isn't enough lemon yellow paint for us – though later I borrow some from Chris, who's brought his own. Also, the colours are getting muddy because I'm not changing my water often enough, and I haven't enough room on my paint tray. John suggests scraping the paint off and replenishing the colours. As I'm using a tray, I have to wash off the paint. Perhaps a palette or baking tray would be more user-friendly.

John says the images in my painting are strong. This is strange really, as I don't intend to paint this way. When I ask John whether each individual has their own intrinsic style, he says yes, but this develops and changes throughout life. Jack says my painting has style. I begin to look at it with different eyes.

After each class I put the painting I've done on the kitchen worktop and look at it every so often during the week. Later this week I wonder whether the strength of the images in this painting might reflect some

Fruit and Tissue, 2006
8-colour gouache plus tissue collage on paper, 60x42cm (23½ x16½in)

In retrospect:

John's comments about my work made me think about it in a fresh way. I thought how strange was his use of the word 'strong', when strong was the last thing I felt at the time. This proved that one's feelings may not be what others perceive. I didn't set out to paint a strong picture. And looking at it I couldn't even see that it was strong.

There are lessons here about conscious intention and unintended results. We're all too aware of the concept of collateral damage in modern warfare. What starts off as a seemingly reasonable endeavour can so easily end up with hideous unintended consequences. But this is the case for almost everything we embark on in life. However well we plan, we can't predict every possible outcome. Being an inner artist is an intensely personal journey. No one starts a painting double-guessing how others will respond to it. Yet whatever our conscious or unconscious intentions, the work will affect others in ways that may surprise us. Because creativity is a way in which the unconscious of one individual can speak to that of another, the receiver's emotional/psychological condition colours his or her perception of the work. This can alarm a novice artist who intends X but is astounded to realize that others perceive Y. This may feel like failure but it isn't. 'I thought I'd simply drawn a picture of a guy battling through the rain on his way home, but Jill saw it as a symbol of her life of drudgery, trudging through a veil of tears, and was deeply moved'.

Such unintended consequences are somewhat akin to having children. All we, as parents, can do is bring up our kids to the best of our ability. They then go out into the world as themselves. How people respond to them is beyond our control and only partly related to how we raised them. It's the same with our artistic creations. Whatever we think or hope, people respond in their own unique ways. As we mature as artists this stops being a source of confusion and gives us pleasure or, at least, interest, as we realise that what we do is in some sense magical in that it affects people in such disparate and unpredictable ways.

inner strength or confidence in me. If so, that's good, because I often feel underconfident and in a 'cloud of unknowing'. Perhaps my painting could help me recognise something I have but don't see.

Some days after, I discuss style with a friend who has an art gallery. She encourages her artists to paint from within, rather than reproduce what sells. I mention van Gogh as I've recently read an article and seen a TV programme about him. My friend says that although the sorts of pictures he painted changed several times in his life, there was always an intrinsic van-Gogh-ness about them – even in his early-Dutch-master period. I know some artists can produce exact copies of other artists' work, so it's clearly possible to override your own style, but maybe when you're doing your own thing, your own style always comes through, however unschooled and amateur your technique. I muse, for the first time, that perhaps a painter's style is like his or her personality.

ART CLASS – year 1, week 16

Fruit and tissue on white paper – mixed-media work

A feast of colour greets me on the trestles. For on the familiar sheets of crumpled white paper lies a profusion of scattered fruits plus tissues of many colours – turquoise, pink, orange, red and yellow – and meandering tangles of green string. It all looks joyous and triumphant, like the wildest of Christmas decorations! I want to paint it. We're to work in mixed media – paint, soft and oil pastels, charcoals and glued-on scraps of coloured tissue.

I think nothing of erecting the easel and board and taping on the paper; indeed, these tasks are as nothing nowadays, whereas at first they were problematic and a real barrier to me marking the paper.

My chosen section has a twist of mauve tissue with a pleasing shape, plus two oranges and two somewhat scraggy pears resting on pretty pink and vibrant turquoise tissue, with some green string curling around.

The Runners, 2006
gouache plus tissue and raffia collage on paper, 56x40cm (22 x15¾in)

I start working in soft pastel, then try applying paint over some of the pastel, and separately. I copy my neighbour in wetting appropriate areas with diluted glue, then tearing bits of tissue and applying them with the glue brush. I use the same brush I used for painting just before, and it doesn't matter to me – in fact I don't even register it – whereas before these classes I would have worried that I should be using separate brushes, and that would have interfered with what I was doing. Perhaps I'm learning not to be ruled by my tools, but to use them for my own purposes and to realize this won't destroy them!

I think my creation looks a mess. But when I photograph it next day and put it on the computer, I like it – which may be because it's framed by white on the screen.

Jack has painted one huge apple with a few indications of white and coloured paper and string around

In retrospect:

Dealing with criticism is a challenge for budding artists. On one hand we seek it, as we try to ascertain whether what we're trying to achieve is getting anywhere. And, of course, we all enjoy approval and encouragement. On the other hand, we fear negative remarks that could send us skidding into despondency.

Whatever art critics claim, there are few absolute truths about anyone's creative efforts. There are certain measurable parameters of technical skill but other than this it's all smoke and mirrors.

What most of us need is someone who will lovingly and carefully encourage us by describing what they see in a non-judgmental way. If there are problems of draughtsmanship that make a bus, for example, look completely unlike a bus, then perhaps a helpful comment such as, 'Could the shadow be darkened here, perhaps, to make it look more three-dimensional', could be helpful. It's also vital to find *something* positive to say about *some* element of the piece – even if only about the enthusiasm and intention! Beware, though, not to fall into the trap met by one art-class student who, at the end of a class, looked at a fellow student's watercolour and said, 'Oh! I do like your pigs!' The artist – a friend of my artist friend John Snow – responded, 'Thanks very much. They're cows.'

The novice artist and especially the inner artist is a tender fruit that's easily squashed. There are no prizes for doing this. Some people's negative comments come from jealousy or envy but most are purely thoughtless. As in any creative world, you'll need to develop a thick skin so as to benefit from criticisms that could drive your work forward yet remain immune to those that say more about the critic than your work. This can take time and maturity.

The painting/collage I did today has turned out to be the one my husband likes best of my work. And it's many other people's favourite, too. I call it 'The runners' because I see two people running in it. But other viewers see different things: one sees a breastfeeding woman and baby. Over the years I've learnt to say very little when someone looks at any of my paintings. I give them the space to form their own response and interpretation.

the edges. It looks strokable and very edible.

I've brought all my art-class pictures, a few pictures I've recently done at home, a woodcarving of a bird in a tree that I've just done, and some of the pictures I did years ago, for John to look at and discuss with me. He wants us to go for FETAC (Further Education and Training Awards Council) accreditation and, hopefully, get a certificate (not sure what). Some of what I've overheard him talking about with some of the others has made me apprehensive about this discussion. But his comments on my work are non-judgmental, based on description, and geared to my personal development as an artist. Instead of me inwardly disparaging some of the images I show him, I find myself listening to his comments and involved in a discussion that's both illuminating and empowering.

He says, in summary, that I should present my work so as to demonstrate themes, development, interests and techniques. He suggests I get together, along with a large folder with polythene pockets:

- A montage of several of my simple pre-class pastel landscapes
- My scissor-tailed flycatcher wood sculpture, perhaps with a new painting of a photo I took of it as work in progress, with the chisels, gouges and clamp
- The clay model, plus my painting of it, perhaps with photos of the model from different angles
- Some of my other classwork, with certain pictures grouped – eg, the fruit ones, to show the evolution of technique (eg, how my highlights developed from the earlier white ones to the later pale-coloured ones)
- My art-class log – with each week's log against the relevant work
- New work based on sketches done outdoors that focus on a theme that interests me.

I now feel warm to this forthcoming assessment, as it will be an interesting project to display and explain all this clearly and attractively.

ART CLASS – year 1, week 17

Playing with paint

The art room has a chill in the air and we can't get the boiler to fire, but a large old plug-in oil radiator comes to the rescue. John wants us to concentrate on paint texture and we leaf through his beautiful art books to see how the masters added texture and richness with different thicknesses of paint and different types, directions and patterns of brush strokes. I'm struck by one depiction of lace (by van Dyck), because it's achieved using rough but tiny thick blobs of white paint, giving a wonderful impression of the intricacy of the pattern. John shows us examples of thin and thick washes too.

We're asked to use white or black paper and to try applying paint in different ways and quantities. The dregs of two terms of art-class gouache are at our disposal.

Opening one squeezy pot, I find a lustrous marbled mix of colour – ochre with fantastical streaks of lemon, carmine and blue. I squeak with delight and take a big brushful to show Clare. I add several other dollops of paint to my tray and find two other beautiful marbled mixtures. But there's no white and virtually no yellow.

For two hours I happily daub seven sheets of paper with brushes, polystyrene blocks and my palms. I try using paint thickly. I make prints by laying one sheet on top of an already printed one, and I'm fascinated to see how the print shows the pattern of my brush strokes better than the original. For example, I made a series of green circles by twisting my brush around for each one, and while the marks just look like circles in the original, they have a swirling movement in

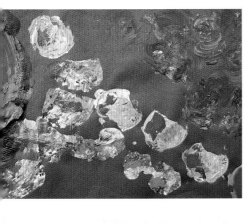

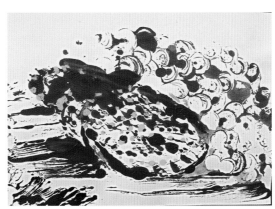

Playing With Paint, *2006*

gouache and paper collage on paper
each 30x42cm (12x16½in)

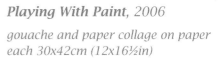

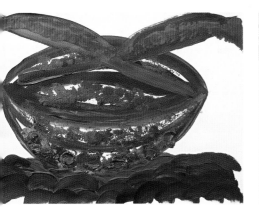
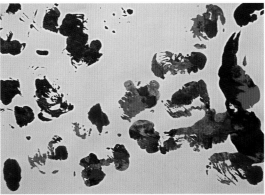

In retrospect:

Looking back on this class makes me focus on the cost of art materials. Being lavish with paint is expensive, as is painting on large supports, so how indulgent should novice artists be?

There's no general answer because everyone has their own financial boundaries. But however much you can spend, you simply don't need the most expensive supports, paints, brushes or frames to enjoy painting and produce lovely artworks. I know that, if necessary, I can be highly creative and have fun with limited resources.

the print, plus greater delicacy. I also try adding thick blobs of colour.

Three of my pieces of paper are ideas for the exterior design of a proposed new arts centre at Kinsale, playing with the idea of making the building like an upturned boat. I go this route because of all the boats and ships that have been lost in Kinsale Harbour or off the nearby coast - and, of course, the Titanic, which left from nearby Queenstown (now Cobh). I snuggle the shape into the landscape and put swirly green trees around it. Between the brown bones of the arts centre 'boat' I add tiny blobs of yellow from a small tube of lemon acrylic paint (which I have with me because we often don't have enough yellow here), to indicate the lights at night. The building looks better when I earth it with shadow at the side and the base.

I notice that I much prefer what I've done on the black paper, though some of the colours have sunk in and got lost. I must remember when I use white paper to cover it with a wash first.

Ten minutes before the end, I'm completely bushed. This play is hard work! But it's reduced my fear of paint, paper and brushes ... the feeling that they come between me and my painting ... and my concern not to waste paint. I'll play more with the boat idea at home – perhaps

to incorporate sails, flags, masts, sterns, prows and the concept of rebirth, rising up, uprising, refloating, survival, triumph and the lifting of spirits.

ART CLASS – year 1, week 18

Fantasy landscape

Our last class of the ad-ed year, and just three of us, Clare, Emer and me – plus John. Our project is to take bits from the images we made when we played with paint last week, and create something new. The idea is to get us re-using images we've already made. We can choose green, black or white paper, and whatever colour media we like. Just as we start, Clare squeals. A small but lengthy slug has appeared on her sheet of white paper. We gape at the creature and wonder at the mystery. Clare had been gardening, so perhaps it had clung to her all the way to art class. Two days later, she emails a photo of Gauguin's Tropical Paradise for my portfolio, plus one of the slug. I email back that maybe we should start a 'Slug Art Group' for the summer.

Clare has started an under-sea picture in clear sharp bright colours and I feel a bit envious. Emer is well away with preparing her work. Back to my project, but my mind is blank and I feel hopeless and helpless. Clare gives me some shapes of multi-coloured dried paint from last week,

as I liked them so much that I'd said I wanted to kidnap them! But I still don't know what to do.

Then I look again at my images from last week, see the deep blue and black marks as if for the first time, and realize I like them a lot. They look like black fir trees against a late night indigo sky, so I cut them out, try them on different coloured papers, and position them like a night horizon in Switzerland at the top of a black sheet. But now what? Every stage seems a struggle. My next favourite images are jade green swirls, so I cut them out then position them to form a woodland that looks green because it's closer than the fir trees. My third favourites are ovals and circles of carmine and blood-red paint, veined because it's so thick. I cut them out and arrange them as petals of flowers, but that doesn't work. So I make them into a path – the 'yellow-brick road' from the Wizard of Oz, but made of red rose petals. I get the perspective wrong – the smaller pieces should be further away. Perhaps this adds to the unreality of this fantasy landscape. But now melancholy kicks in. I don't like what I've done. It's boring. It doesn't make good use of the beautiful blue and black shapes. I look down dejectedly and don't look up as John comes to view what I'm doing. After a long look – his trademark look, and very useful because it's beginning to train me to look and keep looking – he says that the bits of paper left over after cutting out images often have interesting shapes. He picks up some white paper left from around some green swirls and tries positioning it in different ways on the bare green part of my paper. No, I think. I don't like that. But my energy level rises. I take the best piece of multi-coloured dried paint and cut it into a tree. I like it. I then stick it on some green paper and cut the green paper so it makes a narrow border around the tree. Then I find a good place for it

Fantasy Landscape, 2006
gouache plus paper collage on paper
30x42cm (12x16½in)

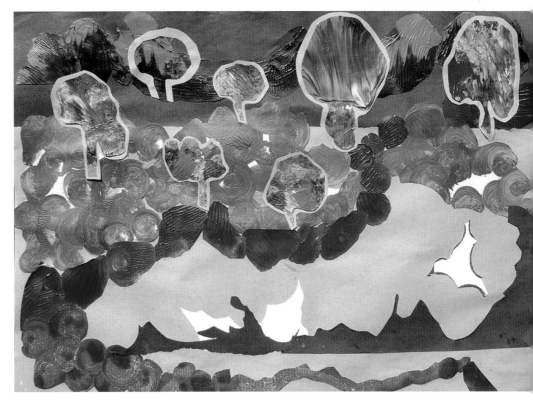

between the woodland and the horizon. This looks surprisingly good. I repeat the idea with five other pieces of multi-coloured dried paint. These green-bordered trees stand out well and I begin to like my picture. The sixth tree uses just a green border against the blue and black horizon. That's best of all. John is interested and says how well the border idea works. He says an idea like that can be used again in other pictures.

Now I don't want to stop, though it's time. I find interesting offcuts of black and white and make fantasy shapes, some of which become seagulls. How strange to move from being bored by a picture, to loving it, within 30 minutes.

We eschew going for a drink in favour of meeting at the weekend. We plan to get together to paint.

Thinking during the week about what we've done, I realize that the idea of using parts of what I've done before, to make something new, is very important to me. So often I imagine I have to create from scratch. But the idea of owning past endeavours and building with them is exciting. The art class and what it's awakened in me means a lot. I'm looking at things and enjoying them more. I feel more rounded. And I can't wait to do more in Year Two.

In retrospect:

What a lesson this week was. It's all too easy – and indeed only human – to focus single-mindedly on the task we're trying to achieve. There I was cutting up images and becoming involved with them, yet what transformed the resulting artwork were the off-cuts I'd at first discarded! Every time we make a mark (or in this case a cut) we create something new around it. When cutting out a disk, we create a hole. This hole could turn out to be more valuable to us than the disk we so cherished. This foreground/background dichotomy and the notion of unintended creativity are always there to be found, if only we can see them.

Another understanding I've come to, as a result of this lesson, is that I repeatedly forget that I can use completed work to make something new. I'm the sort of person who's naturally better, metaphorically speaking, at planting and tending to seeds rather than enjoying blossoms and picking fruits. So my avowed intention is to become a more rounded gardener of my creations. Allied to this is my observation that many successful artists harvest an interesting or otherwise productive idea by doing a series of artworks in a similar vein.

ART CLASS – year 2, week 1

Light and dark – charcoal sketch

Although this class was the second of the new ad-ed year, it was my first, as I forgot last week. This seems extraordinary, because I'd been doing masses of painting throughout the summer; I was experiencing what felt like an explosion of creativity and I'd also played with paint and collage, visited several art exhibitions, and much enjoyed reading a set of partworks about the Old Masters. But there were two reasons why my forgetting the first class probably had Freudian overtones. First, perhaps something inside me was afraid that this year's classes wouldn't be as much fun as before – in other words, a let-down to my current enthusiasm and activity. Second, I felt a little uncomfortable about seeing John, our tutor, because during the summer I'd asked him to my house for lunch with one of the other students plus a gallery owner I know. He'd said yes and I gave him several possible dates, but he didn't call back, even after I bumped into him in the supermarket and reminded him. So I felt rejected. (Though I now know the real reason he didn't want to come.)

Apparently there were five people last week, but 17 turned up this time. John is away for the first three lessons, so a colleague, Ian, is covering. I arrived straight from the airport, 20 minutes late, as my flight had been delayed by two hours. On opening the studio door, I saw a strange tutor plus a room full of people. It was discombobulating and a bit embarrassing, as I wasn't sure if I was in the right place and I felt awkward turning up late. But once assured this was indeed my art class, I swiftly apologised and slipped into a chair. I then saw three of the other four who came each week last year, plus a woman art teacher I'd met in the summer and encouraged to come, plus another familiar face who'd come to some of last year's classes. So all was well.

Last week they'd had an introduction to indicating light and dark with charcoal on paper, and had drawn an apple.

This week we were to focus on using light, dark and size to give a sense of perspective. We had a smallish piece of thick, textured paper, plus a putty rubber and an ordinary rubber, and had to draw without lines, but adding shade and rubbing out as necessary. I did a glass bottle plus an apple and a swathe of black material.

Ian told us to work fast and energetically. He wanted to hear charcoal snapping! And he wanted deep blacks and bright whites. Working so fast gives little time to

Bottle and Apple – 'Light and dark', 2006

charcoal on paper
38x28cm (15x11in)

faff around. He said it's best to cover all the paper and progress every-thing, rather than focus on one area. When he told me that, I filled in the gaps (in particular part of another student's clothing and part of their easel) and my picture immediately looked better. This was because including all the back-ground gave perspective to the whole, and meant that bare white paper didn't jump out and therefore come forward. I enjoyed the lesson, if not the subject matter, which was rather dull. As the evening pro-gressed I soon found a familiar smile on my face, and we all laughed at the tutor's jokes. I like the bottle I've drawn.

The class felt packed. I found myself like a child wanting to stand out. But several of the others' drawings were better than mine, which put me in my place. When we looked at one another's work I found myself making trite remarks about how good some work was. It's a nervousness thing really. It's much better to look carefully and respectfully and, if anything, just describe, like John always did last year.

For homework we're to practice with charcoal. Next week we're to come with a putty rubber and other erasers, plus something interesting to draw that will lend itself to demonstrating light and dark.

ART CLASS – year 2, week 2

Focus and blur – charcoal sketch

I forgot my second art class last night! This was my second forgetting!! But I arranged to go this morning, as we can swap the Monday-night class for the Tuesday-morning one if we want. I rang Emer (a fellow student from last year) to check the time of the class. We caught up on what had happened to each of us over the summer. She was going to the morning class too, which was good because I was feeling apprehensive about going to any art class, let alone the Tuesday one where I

In retrospect:

The salutary lesson from this evening was that whatever our initial mood, creative energy can still emerge. My husband is an author who has written more than 40 books, and people forever ask how he copes with writer's block. He responds that a professional can't afford the luxury of such a thing. Whatever his mood, or life's circumstances, he gets on with the work and meets the publisher's deadline.

It's the same for artists. We need to do the best we can with our resources and not make perfection the enemy of the good. By waiting for ideal conditions we miss out on wonderful opportunities.

The other point from this evening that has stayed with me over the years has been the importance of progressing every part of a picture in tandem, rather than to focus on finishing any one area.

Vase and Block – 'Focus and blur',
2006

charcoal on paper
38x28cm (15x11in)

didn't belong. Either I'm much more neurotic than I thought – or perhaps it's normal to be this way.

So I arrive. Ian, the temporary tutor, is there to introduce the class and hand over to John, the usual tutor. Ian looks at some of the previous week's homework, and says we can learn as much from negatives in a drawing as from its positives. He also points out that very light areas stand out, making them seem closer to the viewer.

Today's task is to choose a layout of objects (eg, vases, apples) on white crumpled paper strewn with folds of black fabric, and draw it in charcoal. But we're to focus only on one object.

In retrospect:

Giving up is the eternal dilemma when we're starting out and sometimes even long after. How I yearned to slip out unnoticed. Yet staying on led to something good.

When being creative it can be hard to know when to quit. Persisting with something can produce a positive result or make us grumpy or resentful. If in doubt I tend to stick with things when I'm feeling rebellious, as in this class.

A related problem is finishing. Some artists find it impossible to complete a work. It's as if asserting it's complete shuts the door to further change. Not only is this daunting but it also invites the question of whether that's all there is! As long as we can tell ourselves it's work in progress, both we and others can be kept waiting for the final transforming touches of genius! But all this is about a lack of confidence. Many professionals say they never declare a work finished; instead they know it could always benefit in time from some tweaking or embellishment. Other artists claim to know the moment something is complete and say that doing anything more would be a mistake.

As with so many creative dilemmas, there are no right answers. Try to recognise whether you seem never to complete anything to your satisfaction. If so, could you have an unconscious addiction to perfection? Could you be making the quest for perfection the enemy of the good?

Vase and Block – 'Distance and connections', 2006

charcoal on paper
56x38cm (22x15in)

Everything in front, behind and to the sides is to be blurred and we must never look at it directly. The aim is to use clarity of line together with greater light-dark contrast to give a sense of perspective and distance between things. The explanation went on forever and I found myself bored and thinking 'I don't want to do it'. At one point I thought I'd kill time by going to the loo. Then I thought I'd slip out unseen and go home. I also felt upset, dejected and disappointed. (There's a huge amount going on in my life, so perhaps I was just feeling ultra-sensitive!)

But I get my easel and board, tape on a large piece of smooth paper, collect some charcoal and an india rubber and choose my set-up – a lovely oddly-shaped carved block of well-grained wood, pine, I think, plus an apple in front, a vase to one side and a couple of small vases behind. Ian had said it could be a good idea to cover the paper with shading first, then add to it for dark areas and rub out for light. So I do that. But one of my neighbours, a tall young guy with a brilliant smile, called Paul, taps me on the shoulder and says it would be better just to plan my drawing on the smooth paper (which Ian had said, but I'd forgotten), then do the actual thing on a smaller piece of thick paper which will hold the charcoal better and allow me to work on it. So I set to with a small piece, using a plastic slide mount first as a

viewfinder to frame my set-up and choose a view. And I start enjoying myself. The task is much easier than I'd thought, and I love the grain and strange shape of the block of wood, and the curve of the vase in the corner of my eye. I no longer want to escape, and the time goes all too fast. I have a peek at what the others have done, then, before leaving, say goodbye to Emer. She asks if I'd like to join several of them for lunch – I can't today, but it's lovely to be asked.

ART CLASS – year 2, week 3

Distance and connections – charcoal sketch

I go on Tuesday morning as I'm tired out the previous evening, having driven from Skibbereen to Dromoland Castle and back (an eight-hour round trip) on the Sunday. Our task is to draw a group of objects (vases, bottles, etc, on assorted sheets of paper), so as to demonstrate the distances between them from front to back and side to side. We're also to incorporate the lessons we've learnt about:

- Differentiating dark and light
- Focusing on one thing, sometimes using an object's surroundings to indicate its edges
- Filling the whole piece of paper.

I find myself automatically using a plastic slide-mount to choose a view,

and using my stick of charcoal to help me assess how big to draw each object. When I've done either of these before, it's seemed a chore, but today both are useful.

I feel relatively emotion-free, and just get on with the job. I particularly enjoy sketching the spiralling undulations of the white vase, the lip of the tiny cylindrical vase, and the vague indications of grain in the wooden cube. It's also pleasing to fill in all the paper, and I sense a new confidence about doing this by drawing in what I might previously have considered boring and unnecessary material. In fact, the background details towards the top of the paper really do lend a sense of perspective and distance. They also add something of an air of excitement (almost) at what might lie outside the snapshot I've chosen.

All in all, I feel more able at drawing … more professional, perhaps. I'm using learnt skills, and it's a good feeling.

This is where the good teacher knows how much to support and when to back off.

In retrospect:

This was probably the first time I felt I was becoming more professional. This break-through comes when, after much struggling, you realise you have enough skill and knowledge to hear your own voice and see with your own eye. A teacher can take you only so far – the rest of the journey is essentially personal, however much help and encouragement you get. While we may learn further technical skills, our main challenge is to learn to travel with our inner artist.

The challenge of starting to feel professional is that you have to begin taking responsibility for your work. This is a bit like an adolescent growing up and preparing to leave the parental nest. While they aren't mature adults, they feel capable of giving independent life a go, albeit with parental backup when needed. This early experience of professionalism is fragile, though, because our new-found skills are easily subject to setbacks, and our confidence soon battered.

ART CLASS – year 2, week 4

Inside and outside the line – charcoal sketch

Tuesday morning again, as I was travelling back from the UK last night. I've noticed that the West Cork Arts Centre booklet bills the Tuesday class as being for beginners, and the Monday evening class for intermediates. But they seem the same level to me.

Today we're to choose a selection of objects (on sheets of paper) to draw, and show their surrounding lines according to whether they are defined by the object being darker than its surroundings at that point, or the surroundings being darker than the object. Different parts of an object's line will be defined by what's inside and what's outside it. The concept seems difficult, even abstruse, as we listen to John, but I sense it might have legs.

I quickly settle and start, relatively oblivious to the other students, and John. I use the 'what's inside, what's outside', concept with the nearest object, an apple, and it almost immediately makes sense. It's actually one of the best tips I've had about drawing. It's so simple, yet so effective. Like last week, I sense an extra confidence in myself. The sound of this 'drawing-for-painting' course didn't much

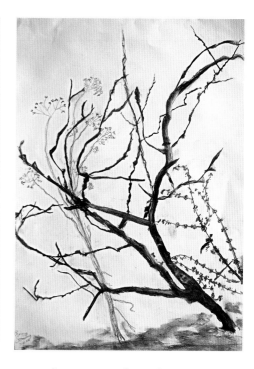

above (from left to right):

Bottles and Apples – 'Inside and outside the line', 2006

charcoal on paper
56x38cm (22x15in)

Making Marks with Charcoal, 2006

charcoal on paper
57x40cm (22½x15½in)

Branch – 'Being free with charcoal', 2006

charcoal on paper
57x40cm (22½x15½in)

In retrospect:

The drawing-for-painting notion of this course began to make real sense that morning as I started to master more techniques. Looking at my sketch I'm delighted with the transparency of the bottle and plan to do more drawings or paintings of glassware.

appeal to me at first, but I can see I've already learnt a lot.

My drawing of the apple plus a glass jar and another apple is simple but has a surprising air of reality. John says I could make my marks more softly, which surprises me, as several people in the class draw very dark sketches.

ART CLASS – year 2, week 5

Being free with charcoal

Tuesday morning yet again, as I was too cosy and lazy last night to leave home. The tables are strewn with

twigs, branches and dried flowers and seed heads, and our task is to draw them using charcoal in lots of different ways. First, though, John encourages us to mark pieces of paper using sticks of charcoal in as many different ways as possible. I use the ends, points and sides of large and small diameter sticks of charcoal. I look for the differences in the types of mark I can make while holding the charcoal in a pencil grip, with my fist, with both hands and with my left hand. I even try holding it with my mouth, but not for long. It's good fun, it loosens me up and it makes me smile.

Next we're to choose a section from the vegetable matter on the table, and do a charcoal sketch. I'd chosen what I wanted to do as soon as I arrived. It's a small, bare, dark branch, with a few seed heads on stalks behind it. I size my drawing so as to make good use of the whole piece of paper. The side of a small stump of charcoal is perfect for producing gnarled twigs, and I sense a visceral pleasure in copying their various angles and bends. I'm bolder than usual, and not afraid to make my mark. I then use the charcoal with soft pressure to draw in some long delicate stalks and their frondy puffy seed heads. I think my composition has a Japanese air and feel pleased with it. When I've finished, I leave, because although there's another 20 minutes to go before the end of the class, I don't want to do anything else to my picture, and I don't feel like starting another. John is out of the room, in the office, I think, so I say goodbye to the people nearest me and slink out. When I get home, I put it on the worktop in the kitchen so I can look at it every time I go by. Last year I did this with everything I brought back from art class, but this is the first time I've done it this year.

In retrospect:

The ready confidence to make my mark was the big issue here. By now I was painting and drawing as much and as often I could, and I'd done dozens of works in all kinds of media, mostly outside the class. This, plus encouragement from those around me, had enabled a rapid growth in my confidence. I was also using my camera to create image banks and to reference my artworks. It's important to note, though, that none of this inner confidence had anything to do with arrogance, or the notion that I'd somehow made it. Once you start working with your inner artist, you realise that your mutual journey is a lifelong one. The daily lessons you learn keep you humble.

ART CLASS – year 2, week 6

Composition in black ink – vase of dried grasses and seedheads, 1

Monday night again. It's a slightly smaller class than the Tuesday morning one, and most of the faces are more familiar. This week we've all brought in a plant or something else organic – John had to ring me to tell me what to bring because I'd scarpered early the week before. After some debate I selected a large cylindrical clear glass vase with some stout dried seed heads and lots of flimsier dried grasses, curling at the top, all tied up with raffia. John says we're to use only black ink! He pours it from a big bottle into tiny little eggcup-sized containers, one for each of us. The first student to pick up her container knocks it over instead, spilling permanent black ink all over the table and on to the floor. Two or three of us help her mop it up with kitchen paper and cloths, and I can feel the atmosphere lightening as she says it would be her, and we say thank goodness it wasn't us!

John demonstrates how to make ink washes of different tones. It's fascinating how few drops of ink it takes to make a really dark wash. He starts a demo pic, explaining that we can use anything we like – eg, brushes, twigs, cardboard spills – to apply our ink washes and lines to

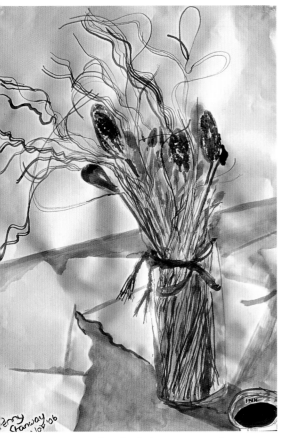

Vase of Dried Grasses and Seedheads, 2006

ink on paper
56x36cm (22x14in)

the paper. We then begin our own. I find that holding a couple of bits of twig together makes superb curly grass tops and parallel stems, and a cardboard spill is great for making wide uniform lines. The ink is lovely to use and I'm pleased to have this chance as I'd probably never have tried it if left to my own devices. I'm pleased with my picture, so I sign it and bask in a rosy glow of contentment as I drive home.

In retrospect:

Once again I learn and grow from the restricted choice of media and tools. Using the twigs to paint with felt great...and produced a very pleasing result. This piece hangs framed in a prominent place at home and many people say they love it. Little do they know its humble origins - a messy pot of ink and some twigs as a 'brush' - or that the whole thing was completed within an hour.

ART CLASS – year 2, week 7

Composition in black ink – vase and dried grasses and seedheads, 2 and 3

Back to the Tuesday morning class, making me feel somewhat out of place as I'm really a Monday evening student. We're to repeat the same subject as last week, doing it in ink at least once, so as to get more used to the medium and loosen up. Several people like my vase of dried grasses and seedheads, and position themselves so they too can draw it.

While I feel a bit more at ease with the ink this week, and mark the paper more confidently with the ink plus twigs, cardboard spills or brush, I'm clearly not that much at ease, because my first attempt is almost a replica of last week's. So I start afresh.

This time I make bolder strokes. They're darker, too, and I concentrate more on the basic shapes of the seedheads, etc. Then when darkening one seedhead, I use such a lot of ink that it floods

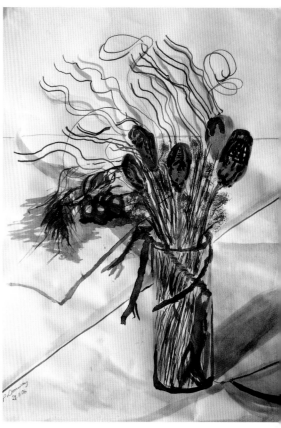

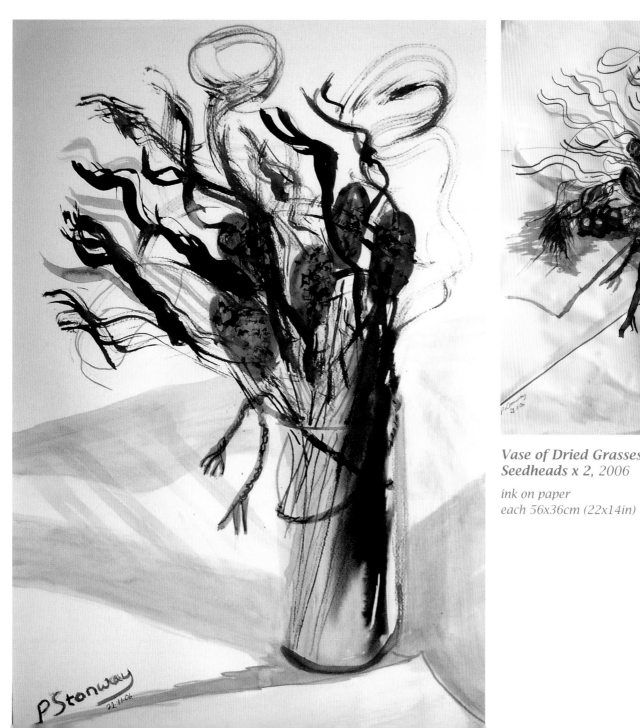

Vase of Dried Grasses and Seedheads x 2, 2006

ink on paper
each 56x36cm (22x14in)

downwards over the paper. John comes past and says I can make use of the flood to good effect (or something like that!). So I brush the surplus ink downwards to give the impression of shading. And it looks good. I think it's the best of the three studies, and it's certainly the most painterly.

In retrospect:

The ink spill this week was a happy accident such as described by the artist Bob Ross, as this particular sketch was by far the best of the three I did of the vase and dried grasses and seedheads. I find now that I can almost always use accidents to my advantage. They don't scare me any more and when they occur I welcome the opportunity to work my way out of them.

Bunch of Bindweed – 'Tones', 2006

ink and gouache on paper
42x59cm (16½x23¼in)

ART CLASS – year 2, week 8

Tones in ink and white paint on grey paper – bunch of bindweed

Monday night and it's dark, windy and wet. We're supposed to have brought something organic to draw, but I forgot. Clare did too, so we went to the car park and she cut some evergreen twigs while I gathered an armful of dead bindweed. John wanted us to draw our subject using various tones of ink wash, plus white paint, on grey paper.

It was by far the hardest thing I've done in art class, and I very soon wanted to give up. My bunch of bindweed looked a complete and utter mess, and when I tried to insert some white areas, I realized too late that the bindweed was lying on a large triangular piece of white paper, so I should have painted the background white first. Or perhaps not because that would have meant the ink would have run into the wet white paint. 'Whatever', I thought, 'That's it. I'm useless'.

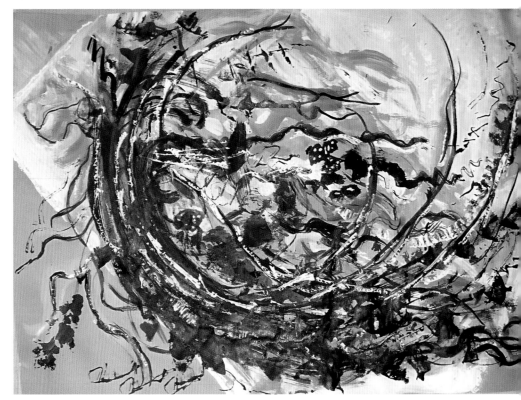

John came past and I said it looked like complete chaos and was the worst thing I'd ever done. He looked for a long time and eventually said it was often possible to work on and find a better picture emerging. He suggested strengthening the basic shapes – eg, the main swirl of the bunch.

I did this by brushing on dark black ink tones for the stems, highlighted with the white-paint-soaked corrugated edge of a cardboard spill, and stamping with an ink-coated dried oak leaf. I also used two fine twig points as nibs to draw thin curly tendrils. And I strengthened the edges of the underlying white paper with the side of a white-paint-soaked cardboard spill.

John stopped and stared at it several times as he walked around the room. At the end of the evening all I can say is that it's very different from other things I've done. It's striking. It has a certain depth to it. And I like some of the textures and effects. But I think it's disturbing, partly because it's so full of spiralling motion and tangled depths. Life is a bit like that at the moment for me, which could explain a lot.

ART CLASS – year 2, week 9

Tones in ink, charcoal and white paint on white paper – crate and secateurs

Monday night again. At John's request for mechanical objects as subjects for a still life, I've brought

Crate and Secateurs – 'Tones', 2006

ink, charcoal and gouache on paper 38x56cm (15x22in)

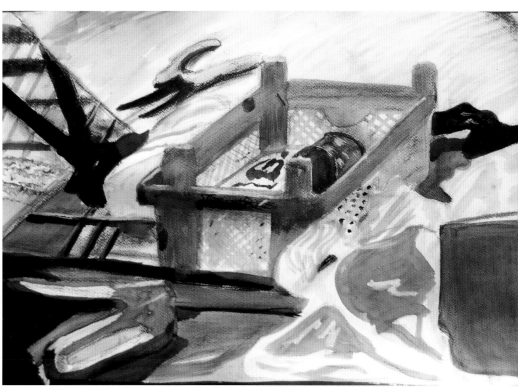

In retrospect:

It's easy to make a premature judgement about something I'm working on. The lesson here was to be patient and give the work time to evolve and mature. I'm now quite fond of this ink and paint sketch.

*Tray, Box, Bubble-wrap, 'Tones',
2006*

*ink and white paint on paper
56x38cm (22x15in)*

in secateurs, a jointed wooden artist's mannequin, and something else I can't recall. I add these to the huge tableau of assorted plastic crates, metal bars, bubble wrap and cardboard boxes already in place. We're to choose a section and get going in mixed media, as above, to show tones of light and dark. Using a plastic slide mount to frame various views, I opt for a section based on a plastic crate with the secateurs behind.

As I draft this mini tableau, I realize that my confidence in seeing and depicting tones has increased this term. I'm making contrasts more obvious and I'm no longer ruled by the fear that adding darkness will somehow perhaps almost destroy what I'm doing. Darkness in the wrong place can be wiped out or covered over, then moved. While it might appear to be in control, it's in fact controllable ... by me! I also realize that I like each of my three chosen media.

Once home, I'm quite pleased with my quick depiction of what is, to all intents and purposes, a very unprepossessing group. But then I notice that the two pairs of upstanding legs of the crate are not in perspective. The front two aren't at the front two corners, so they are nearer together than the back two. How ever could I have done that? How disappointing.

But all is not as it appears, as I see next week.

ART CLASS – year 2, week 10

Tones in ink and white paint on white paper – tray, box and bubble wrap

Monday night, the usual small group and the same depressing looking mechanical tableau from last week.

John suggests we choose a section that's small. I take no notice, park my easel right back in a corner of the studio, and select a relatively large section. Why? Perhaps because I'm not used to the idea of making things

In retrospect:

If being a good creative artist were simply about becoming an accurate draughtsman, we could simply learn to be more skilful and adept at drawing. But looking back at this picture makes me realise how little it took in the way of making marks to give a plenty good enough impression of the plastic mesh at the sides of the crate. If at first sight a subject seems impossibly daunting, aim to reproduce just a little of each area of detail, so as to fool the eye into thinking you've done it all.

simple for myself. Perhaps because I'm bolshy and don't want to be told. Perhaps, more prosaically, because I want to include the whole of the shiny tray that's propped against a box.

But the section I've chosen is rather too challenging for my liking. It's hard to make the bubble wrap look realistic. I can't make the wires dangling in front of the tray look authentic – using twigs or paper spills as 'brushes' doesn't work as the paint runs out too quickly, while the art-class brushes are much too big.

Despite all these challenges, I'm pleased to realize that I'm putting various lessons into practice. I'm naturally filling the whole piece of paper rather than concentrating on one area. And I'm automatically using sharply contrasting tones when necessary.

Towards the end of the class, though, John comes and studies my picture, then points out that adding some more highlighting to the tray would make it shine more. And it does, even with the clumsiness of my thick brush. I muse again how just the suggestion of brightness makes all the difference – the shape and size of the highlights don't have to be perfect. The mind's eye makes up the rest. And perhaps the presence of imperfections allows us to imagine more in a picture than if everything looked as real as in a photo.

In retrospect:

I really struggled that night, yet when looking at the picture after a gap of several years, I realise nothing needs to be photo-perfect in order for the eye and brain to make sense of them. In fact it's quite the contrary. Given that our brain interprets so miraculously what the eye perceives, it frees us to take liberties. Many of these liberties are visual shortcuts. The great Masters took all kinds of short-cuts and there's no reason why we can't do the same.

ART CLASS - year 3, week 1

Gouache on white paper - yellow geranium

Big class, too crowded. Came with my friend Linda and her friend who teaches English and hosted a cookery workshop with Sarah last year.

Clare emailed me before the class to ask if I was coming, which made me feel more part of it. I'd spent the summer moving home and being in London a lot, so I felt very out of touch.

Geranium, 2007

gouache on paper, 42x59cm (16.5x23in)

Am writing this up several weeks later and I forget the purpose of our task, which was to paint (or use any other medium) something natural we had brought in. I painted someone's potted plant. I felt uninspired and rebellious and decided to paint each part of my subject in its complementary colour, so I did the leaves red (not green), flowers yellow (not purple), pot green (not red). It didn't look great!! And no one noticed. The only things I enjoyed were setting the pot in its place by filling in some of the background; shading the pot with

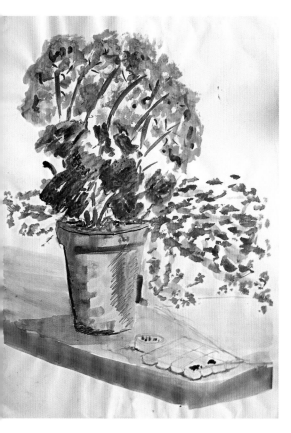

some diagonal squiggles, dark lines and darker paint brushed on wet paper; and painting some fine detail on the table by the pot.

I also did a very quick painting using more appropriate colours.

Must remember if I do flowers en masse again to take heed of Rolf Harris's tip, which is to do just one or two flowers in detail. The eye then imagines the rest in more detail than you've actually done.

ART CLASS – year 3, week 2

Naval ship off Whiddy Island

I'd missed September 17 (as I was in London) and 24 (as I had flu), and October 1 and 8 (as I was in London),

and was surprised to find the class much shrunken. It felt much better as there was more room to move.

Clare had said on the phone that we were to take in photos of something we'd like to paint. I took photos of a naval ship about to steam away from Whiddy Island, and a pirate ship from a book. Both were black and white silhouettes.
John suggested sketching from an upside-down photo, which I did for the naval ship. I used charcoal for the sea, then black ink and brush for the ship. My ink had gone off and smelt of rotten eggs, so I used John's.

I did my sea and naval ship fast and loved it. The fine detail seemed as nothing as I didn't know what I was drawing and so it didn't seem to

In retrospect:

Another lesson in disengaging the left side of my brain. I'm learning more and more about painting or drawing quickly without too much scrutiny. It's strange – or perhaps not – how several of the paintings I've done particularly quickly have been more attractive to me than those done with greater care.

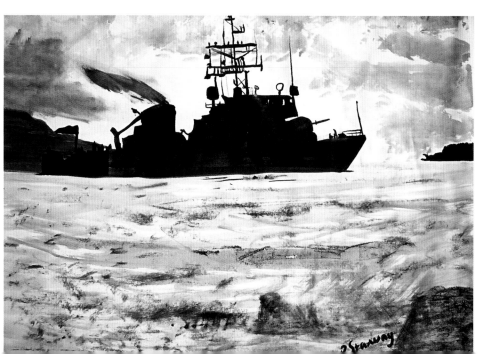

In retrospect:

Another quick sketch and one that now hangs framed in my studio. Many people like it and some think it looks like a photo. But, of course, it doesn't because it isn't nearly detailed enough. But for all that it has far more menace. Living by the water in Ireland, I repeatedly marvel at the silver turquoise water of Bantry Bay. This scene sets off the black ship beautifully against the shining ocean. Knowing nothing of what such a ship should look like made it easy to turn my reference photo upside down and simply paint what I saw. If you just keep looking, you'll find the answers in front of you.

far left: *Yellow Geranium*, 2007

gouache on paper, 59x42cm (23x16½in)

left: *Irish Naval Ship off Whiddy Island*, 2007

charcoal and ink on paper 40x57cm (15¾x22½in)

right and on following page: *Life drawings of female model x 5,* 2007

charcoal and chalk on paper each 59x42cm (23¼x16½in)

matter. The finished ship has an air of menace and I am very pleased with it. Jack liked it and asked why I didn't bring in good paper, as the art class paper is very light and had wrinkled.

The pirate ship is less successful, partly because I didn't have much time.

ART CLASS – year 3, week 3

Life class, female model

Went in Linda's car, with Christine, and discussed art class all the way. About 10 people were present. The life model was perhaps in her mid-40s, very thin, with a lovely face, a cap of short dark hair and a widow's peak. John seemed to be acting in a different mode tonight. Much more in charge, somehow. We started with three 2-minute poses on one sheet of white paper. I used medium-thick charcoal. We then turned our easels inwards and looked at each other's. John made a few comments about proportions. We repeated the exercise, concentrating more on shading.

Then we did several longer single-sheet sketches, including one with white chalk on black paper, which I absolutely loved doing. I found the stumpy chalk very easy to manipulate on its side – which

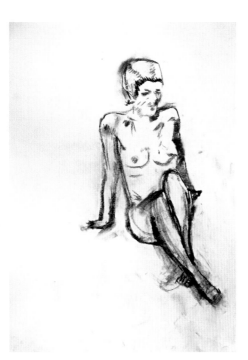

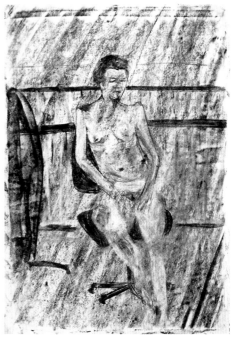

makes me think I should try using really thick pieces of charcoal. I found myself doing a very angular sketch, twisting and turning the chalk as if to caress the angles of the model's face, neck, shoulders, tummy, etc. It felt more like sculpting than drawing and I was aware of thinking how beautiful she was – especially her face.

I learnt a lot this evening. For example, how to use my fingers or pencil to gauge proportions of different body parts, and how to work with a rubber, whether erasing or 'drawing'.

In retrospect:

Simple changes in medium and/or support – as on that evening, from black charcoal used end-on with white paper, to white chalk side-on with black paper – can completely change the experience and reward of drawing.

It also brought an old lesson into focus – how to delineate the edge of the body not with a line, but with a tone on one side or the other.

A NOTE TO FINISH

I hope the challenges, feelings and rewards I've reported here in my log – along with the rest of the book – will inspire you, too, to enjoy painting with your inner artist.

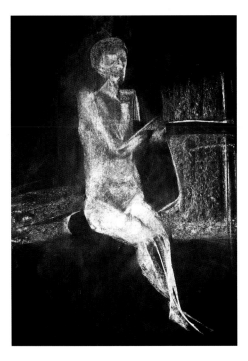

Index